Going Back to Galveston

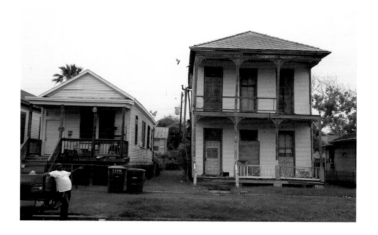

Going Back to Galveston

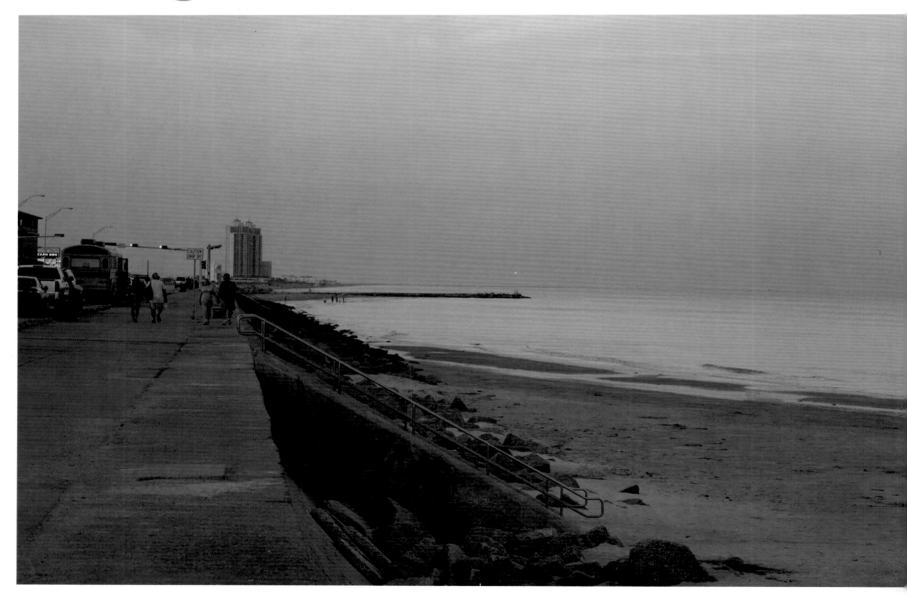

TEXAS A&M UNIVERSITY PRESS COLLEGE STATION

Nature, Funk, and Fantasy in a Favorite Place

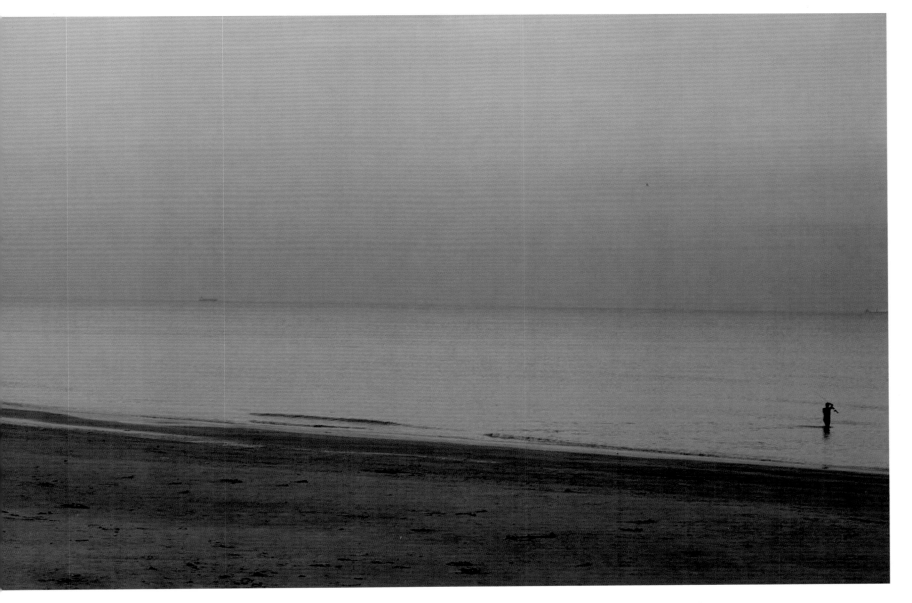

M. Jimmie Killingsworth

Photographs by Geoff Winningham

Copyright © 2011
by M. Jimmie Killingsworth & Geoff Winningham
Manufactured in China by Everbest Printing Co., through
FCI Print Group

All rights reserved
First edition

This paper meets the requirements
of ANSI/NISO Z39.48-1992
(Permanence of Paper).
Binding materials have been chosen
for durability.

LIBRARY OF CONGRESS CATALOGING-IN-PUBLICATION DATA

Killingsworth, M. Jimmie.
 Going back to Galveston : nature, funk, and fantasy in a favorite place /
M. Jimmie Killingsworth ; photographs by Geoff Winningham. — 1st ed.
 p. cm.
 Includes index.
 ISBN-13: 978-1-60344-294-7 (flexbound : alk. paper)
 ISBN-10: 1-60344-294-4 (flexbound : alk. paper)
 ISBN-13: 978-1-60344-295-4 (e-book)
 ISBN-10: 1-60344-295-2 (e-book)
 1. Galveston (Tex.)—Description and travel.
2. Galveston (Tex.)—Pictorial works. I. Winningham, Geoff. II. Title.
F394.G2K55 2011
917.64'1390464—dc22
2010053383

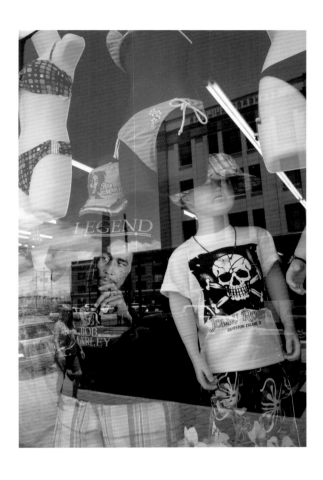

Contents

Going Back to Galveston

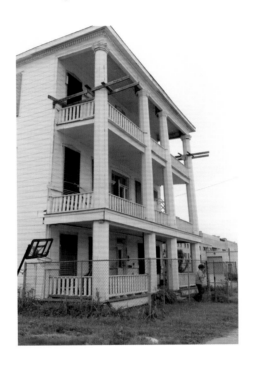

Going Back to Galveston

Prologue

My friend goes to Galveston every June to collect sargasso weed for the junior naturalist classes he runs in our hometown. Sargasso is the stuff that washes onto the beach in warm weather—seagoing brown algae with little grape-like bulbs that allow its leafy stems to stay afloat and follow the balmy currents of the gulfstream. At certain times of year, you have to struggle not to step in it as you walk barefoot on the beach. It seems to follow you around and stick to your legs and swimsuit as you wade in the surf. My friend puts a chunk of it in an aquarium for the kids to study. It's alive, a world of its own—with creatures like the tiny sargasso anglerfish adapted to live within this mobile, miniature ecosystem as it floats in huge mats around the Caribbean and Gulf of Mexico.

It reaches Galveston by chance, deposited there by the same currents that brought the first European adventurers from Spain, from Germany, from Florida and New Orleans. Those people also brought worlds of their own—their livestock, crop seeds, dogs and cats and rats, their arts and cultures, and eventually their industries: fishing boats, big hotels, and offshore oil rigs. Now you can't walk on the beach or wade in the surf without stepping in the evidence of human habitation.

Like the sargasso weed or the human traffic that settles there or passes through to other destinations, I keep going to Galveston. It never became a habitat for me—a wanderer on the currents of modern economy—but it has become a habit.

After a decade or so of seasonal landings on its beaches and bays, I started writing this book. It began as notes toward a natural history of Galveston—the birds and fish, the land and seascapes that kept drawing me back. But soon I realized that natural history and human history are too tightly intertwined on this island to be separated by even the most discriminating focus. So my notes became a study of place, which always involves the human encounter

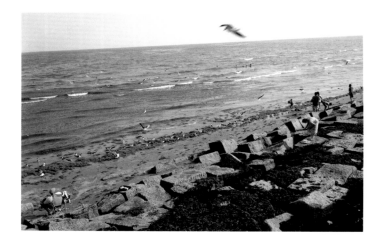

with the found world of nature. Even the wildest and most remote places, where no cities are built or industries developed, are called places because we put them on our maps, explore them, think about them, film and photograph, study and write about them, so that they become objects of human imagination and desire. We shape the world first in imagination and desire, which give rise to virtual places—places we go in our minds, fantasy worlds to which we escape when we are stuck someplace else.

Natural, artificial, virtual—what we find, what we make, and what we imagine—these are the forces that shape Galveston as a unique place, but they are also the forces that create human habitat all over the world today. This book—my writing and the photography by Geoff Winningham—offers an invitation to go to Galveston (virtually if not actually) to contemplate the eclectic character of this place and, indirectly, every other place.

Take warning: like the sargasso weed and the Norway rat, I am not a native of Galveston. No one is anymore, not even the proud "Born on the Island" families. The real natives were driven off long ago, probably by hurricanes as much as by European colonization. Like everyone else, to varying degrees, I bring an outsider's perspective to Galveston.

Nor am I an expert naturalist, a cultural geographer, or an anthropologist. I am only a writer with a Galveston habit. The place has stirred my imagination and earned my affection. But whenever I take someone else there, I nearly always feel compelled to explain my attraction. The reasons are not immediately apparent to many. The telling takes a while, about the length of this book.

Island of Doom

Galveston is a barrier island on the Gulf of Mexico, some thirty miles long, less than a mile wide in places, fronting a wide, deep bay. West of New Orleans and northeast of Corpus Christi, it runs roughly east to west beneath the part of East Texas that lines up with the southern United States (in culture and geography).

It ought to be beautiful, but to call it so would be a stretch. The first time I visited Galveston some two decades ago, just after I was hired at Texas A&M in College Station, I was struck by the filthiness of the beach. It wasn't just the trash underfoot, which was there for sure—fast-food containers, plastic bags weighted with sand, fishing lines

trailing rusty hooks, broken glass, and unidentifiable goop, all mingled with crumbling seashells and strands of neon blue jellyfish competing for attention with gaudy shreds of plastic. What really got me was the persistent oiliness. I had been around beach tar before, but the sand here seemed laced with sludge, the water brown and textured, bearing traces (I assumed) of a continuous leak from the rusty steel of the oil industry offshore. Drilling rigs loomed on the horizon like alien warships from an old B movie; tankers wallowed like monsters glutted with crude.

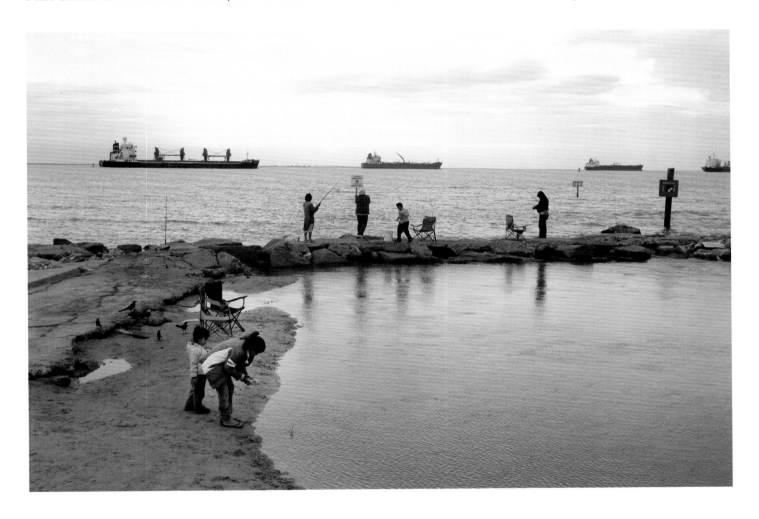

I found out later that the general filth, which I was quick to blame on industrial pollution, actually results from the interaction of natural and artificial forces—the cycles and processes of nature (tides, rivers, topography, and currents) engaging the products and by-products of human industry (agriculture, fishing, oil, and tourism). I learned from an essay by Stephen Harrigan that currents from the entire Gulf of Mexico deposit their burden of human garbage on Texas beaches; trash comes all the way from Florida and the Yucatan. The conditions of nature are not as kind to the practices of overuse as they are on the coast of South Carolina, where I vacationed as a child. There the powerful Atlantic sweeps the beaches clean with every high tide; the rivers rush seaward from the Appalachians at a relatively brisk pace and are slowed by a much shorter stretch of flat coastal plain. By contrast, the nature of Galveston conspires with pollution. Great chunks of pastures, prairies, feedlots, and chemically enhanced cotton fields flow into the Gulf from lumbering rivers crossing the southeastern quadrant of a huge state, itself once half covered by a shallow sea. The rivers flow even slower in recent years. The welling of water to slake the thirst of the big cities and extraction of oil and gas to fill the coffers has lowered the elevation of the ground while sea level increases with global warming and what coastal geologists call "shoreline advancement." Barrier islands like Galveston are always trying to crawl back and join the mainland, to close the bay and leave only a sandbar on the near horizon. Nature tries to swallow Galveston while humanity struggles to save it but usually manages only to mess things up.

And yet the island and its great stretch of bay continue to attract human travelers as they have for centuries. Not only generous to fish and fowl and welcoming to people seeking a way onto the mainland from the Gulf—the pirates and settlers of the past, the cruise-ship passengers of the present—Galveston is placid and lovely to human habitation—most of the time. When it's not, it's really not. One of the first Europeans to land on Galveston, Álvar Núñez Cabeza de Vaca, survived shipwreck and starvation to enjoy the mosquitoes and uneven hospitality of the native people there in 1528. He called the island Malhado, meaning "Place of Misfortune," or better yet, "Island of Doom." Like much of Texas, and increasingly the rest of the world, Galveston is a habitat menaced by disaster and extreme conditions.

I got a lesson about one kind of extreme on my first visit to Galveston, the week after Labor Day in 1990. Newly arrived in Texas, Jackie and I decided to go camping at the state park on the western end of the island, to celebrate the fourth birthday of our daughter Myrth. At about the same age, Jackie, who grew up in Houston, used to go to Galveston with her family. She had good memories of the place. I'd seen the grainy home movies in black and white, the adults playing catch with baseballs and mitts, the kids running amok in surf and sand. They drove their cars onto the beach and stretched blankets between them as tents to protect tired bodies from the sun. Thirty years later, we took a real tent, our trusty dome, and headed for what

looked from the map like a quick trip on good roads all the way.

We didn't count on bumper-to-bumper traffic in Houston at midday, which threatened to overheat our old Volvo. We switched off the air conditioner to prevent calamity as the radio announced a hundred degrees outside. Apparently the Texas summer stretches into September. Perhaps the sea breeze would help.

We arrived on the island late in the afternoon, set up the tent, and dashed to the water's edge for refreshment. But after dipping our feet in greasy warm water and avoiding broken glass on a beach dotted with lumps of tar, we headed back to camp, ate a sandwich, and turned in, exhausted and, yes, disappointed.

The sun drove us out of the tent early the next day. We sweated through breakfast, watching the waters on the Gulf lie still as an inland lake. We sweated down the beach to the bathtub-warm water, muddy and calm in breezeless air, waves struggling to hold their form. By late morning, the heat was unbearable. We broke camp and went shopping, not for the ubiquitous trinkets and souvenirs, but for the relief of the air conditioning. We went to the ice-cream parlor. Finally we gave up and went home earlier than we'd intended.

We had learned firsthand what every Texan knows from legend, lore, and experience. The Texas coast is a convection oven in late summer. Seasonal heat waves create the conditions in the Gulf of Mexico to spawn the hurricanes that, more than anything else, have always shaped the nature of this place and its human history. And the season doesn't end on Labor Day. The great hurricane of 1900 that covered the entire island with water and killed some six thousand people—the most devastating natural disaster in U.S. history—occurred on September 8–9. Hurricane Carla, which struck in 1961, came on September 11. Ike made landfall on September 12, 2008. How good

was the timing of our first visit to Galveston on Myrth's birthday, September 9, 1990, the ninetieth anniversary of the 1900 storm?

That hurricane, from the days before storms were given names, inspired a black preacher serving time for murder in the state penitentiary at Huntsville to write the song "Galveston Flood." The version I heard as a college student was recorded by folk singer Tom Rush in the 1960s. In the current millennium, it was revived by coffee shop and folk-festival musicians after Hurricane Katrina nearly destroyed the built environment of New Orleans and the Mississippi Gulf shore. "Wasn't that a mighty storm?" goes the chorus. "It blew all the people away."

Fantasy Island

Hurricanes have always been natural Galveston's way of keeping the island's built environment in check. A strong hot wind a few notches below hurricane strength might dismantle any of the rickety Gulf-side fishing piers. A Category 5 storm might sweep the island clean.

So what are the builders of the sports bars, the big hotels, convention centers, and chain resorts thinking? Maybe they trust the great seawall, a constant in the character of artificial Galveston, which was erected after the 1900 storm and worked quite well for nearly a hundred years, despite the double tornadoes that Hurricane Carla sent tearing through town in 1961. Or maybe the corporate investors in the island are banking on making enough

money between storms to offset their losses when the big one comes. They could take a tax break and make up the deficit at their Miami or Singapore sites. Whatever the local conditions, they live by the laws of a global economy.

Or maybe they try not to think too much about it. That would be the way of virtuality.

Not thinking about it—losing the mental and physical connection with the natural place and its limits on artificial character—actually seems to be the goal of many new attractions on Galveston Island: Moody Gardens, the Rainforest Cafe, Schlitterbahn, all of which I group under the heading of virtual reality. In virtual reality, you purposely lose sight of where you are in order to see someplace where you are not. You enter the rainforest pyramid at Moody Gardens and leave behind the laughing gulls and Gulf atmosphere of natural Galveston. The air is still humid in the pyramid, but cooler in the shade of real tropical trees. Ficus and other things I think of as houseplants grow impossibly huge. The cries of birds are different, too, uttered by species that would never naturally test the airspace of East Texas, and a few rare visitors, like the striking scarlet ibis, a sample of which I once saw flying over the wet bayside grasslands of the island (though it might have been a white ibis painted scarlet by the sunset). In one corner of the Moody pyramid is an artificial bat cave; there are ponds with monster catfish and other Amazonian wonders. If you crane your neck long enough, you might catch sight of the silent yet surprisingly large tree sloth. If you don't see it, you might smell it—a musky odor not to be sniffed in the natural world on this side of the equator.

Though we are nature lovers and the worst kind of granola-crunching tree-huggers, Jackie and I, like so many of our generation, are also godchildren of Walt Disney. We can't help but enjoy Moody Gardens. In 2006 we bought our first annual pass and visited several times. (Jackie saw the sloth; I only smelled it.) We delighted especially in going to the rainforest pyramid at night, when the bats are most active, and largish quail-like birds look back over their shoulders at you as they scamper ahead on paved pathways.

Most of all, we enjoyed the small ironies. The place has mice. We saw them sampling the bird feed in one exhibit and for a brief moment felt the ironic intersection of the natural and the virtual. Are those mice meant to be here? Of course they are, but not by any plan of Moody Gardens.

We followed a long line of parents with kids into the 3-D theater, put on the funny glasses, and listened to Johnny Depp narrate a film of the underwater world, luxurious coral reefs, ingenious schemes for predation, sharks and rays and colorful clownfish, tentacled anemones and pensive-faced sea turtles. We went "ooh" with the rest of the audience when a big fish seemed to swim out of the screen, as if to land in our laps. Later we tried the 4-D theater and felt little splashes of water and the rumble of movement beneath our seats. "Ooh," we said with a laugh.

We went to the aquarium, where through a thick glass we could watch penguins loitering on a fake Antarctic landscape. We noticed a slightly fishy smell all around but ignored it so as not to break the spell. With a view above and below the surface of the water—like nowhere in

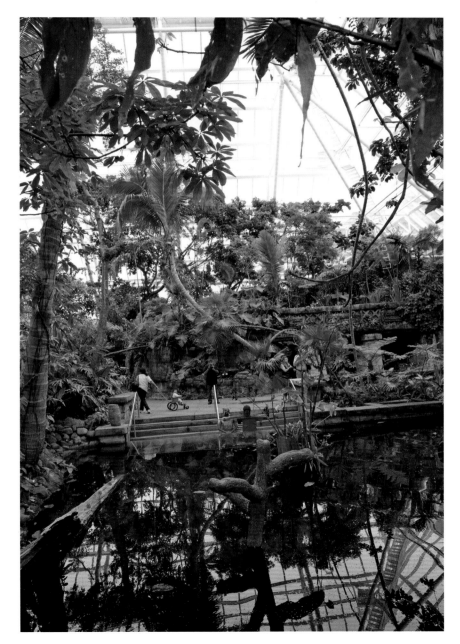

nature—we could follow the penguins' progress as they dove into deep pools and swam like black-and-white bullets, effortlessly gliding at high speeds, then popping up to break the surface—like a balloon you had suddenly released after holding it underwater. They invariably landed on their feet to waddle again among their peers on dry ground. Children with faces pressed against the glass let go laughing, their chubby legs pumping with delight. We followed the crowd through the hall of exhibits to emerge into a tunnel of glass and water where sea turtles, barracudas, great-mouthed groupers, and a big snaggle-toothed shark passed over our heads. "Ooh," we said again.

We saved late afternoon for natural bird watching. But, as we positioned ourselves at the viewing posts set up by the state park, a thick fog rolled in from the Gulf. We sighed and headed back to the car. Such a thing would never happen at Moody Gardens.

That night we met our niece and her little daughter at the Rainforest Cafe and enjoyed decent but expensive food under plastic models of generic jungle flora while at regular intervals big plastic animals—an elephant and some monkeys—awakened, moved their mechanical appendages, and emitted computerized calls. (Members of my generation: think of the soundtrack from a Tarzan movie.) After dinner we stood in the courtyard in front of the restaurant and actually felt the heat when the simulated volcano on the roof of the place erupted with tongues of fire. Across the courtyard in front of a little tiki hut, we watched real Polynesian dancers in grass skirts, demonstrating their art and then recruiting some of the tourist

kids to learn the dances. Later the performers came back in street clothes and joined the same kids in a hip-hop line dance.

The light of the volcano and flaming firebrands set up around the courtyard blocked out any chance of seeing the beach across the street or the stars overhead. We were enveloped in this consensual fantasy of a tropical island—a virtual island on a natural island.

Another day we went with our little group of kin to the dinosaur exhibit visiting at Moody Gardens. In a sprawling tent with mist blown through big fans, we drank chilled water for two dollars a bottle and watched the mechanical movements of simulated reptiles, tails swinging, jaws snapping, heads nodding as if to affirm, "I could eat you too, you better believe it." Virtual history, we learned, overcomes constraints of time as well as place.

Then we took the paddlewheel boat for a tour of the bay. The oppressive summer heat, even with the bay breeze, was too much. It drove us into the enclosed cabin where the view was limited, so the best look at anything I got, beyond the fake wood paneling of the fake paddle boat (actually powered by inboard motors), was a view of the herons and the schooling fish in the water just off the gangplank as we exited the tour. I stood for a while watching the living creatures, transfixed, until I noticed my group had left me behind and had gone to get out of the sun, back to the misty cool of the dinosaur tent.

Later in the afternoon, same day, I stood in the bathwater-warm surf at the eastern end of the island in front of the seawall. The air temperature had dropped to about

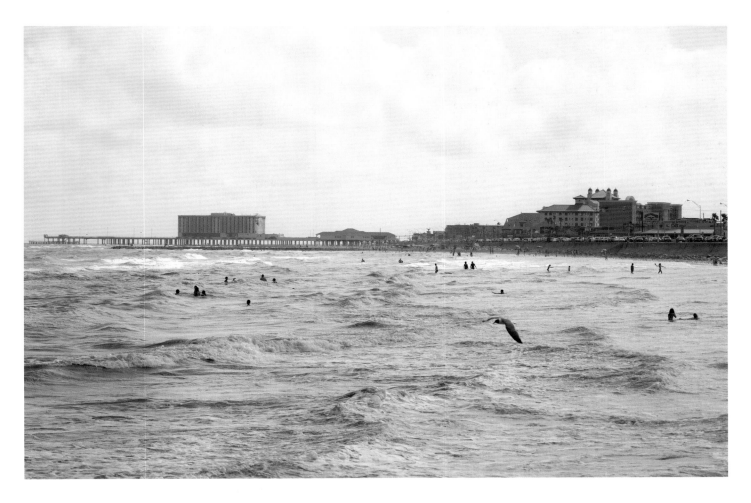

ninety; the water was only slightly cooler. I walked out a long way. It was shallow there. I was barely waist deep after a hundred yards of wading.

Fish were leaping all around me in the muddy water—hundreds of fish ranging from fingerlings to five-pounders.

I had read that the unusually heavy rains of the summer had created a dead zone offshore. The burden of fresh water pouring into the Gulf from the Brazos and other big rivers was floating on top of the heavier salt water. The condition, called hypoxia, creates a freshwater cap that de-

prives the life below of oxygen. The less mobile creatures, like clams and oysters, suffered in place, while those able to swim hightailed it for better water, hurting the shrimp and fish industry. Where had the fish gone?

Apparently to the beach at Galveston, to swim among the sweating tourists. Here they were, in 4-D, close enough to touch. They were leaping into the air—I suppose to discover where they actually were, considering the murkiness of the water. I could see the stripes and colors on their slender forms, right in front of me. "Ooh," I said out loud, my voice drowning in the sound of mild surf and gulls laughing in the sky above.

Catfish on Airplanes

Natural Galveston is an unforgiving environment. The heat, the fog, the filth, the big storms drive you indoors— or inland. But without the presence of the natural beach, virtual Galveston—which is not Galveston at all but the simulation of some other place or time, the portal to which is natural Galveston—could not exist. People "go to the beach," then have to escape it; just as in Tennessee, people go to the Great Smoky Mountains, but after finding disappointment in the distant or fleeting sight of bears or wild turkeys at Cades Cove, or having to herd the children like reluctant mewling sheep up a mile or two of steep, rainy trail to Laurel Falls, they seek relief in Gatlinburg at Ripley's Believe It or Not! or at Dollywood in Pigeon Forge. Nature is too demanding, too subtle, too darn natu-

ral for postindustrial humanity. Virtual reality is convenient and close. It delivers the goods without requiring patience or planning.

Sitting in a nice restaurant in Taos, New Mexico, back in the 1980s, I asked what kind of fish was being served, hoping for a local trout. My friends had caught some noble cutthroats and rainbows in the streams of the Sangre de Cristo Mountains on a recent backpacking venture.

But no.

"We have fresh fish flown in daily," the "waitperson" boasted. "Today's selection is catfish."

"Catfish?"

"Yes, sir."

A vision came of the whiskered monsters cruising the bottom of a muddy river in Louisiana or East Texas. "Why would anyone put a catfish on an airplane?"

The waiter shot me a look of undisguised irritation; nobody at my table was much amused either. I was being difficult again. It was rude of me, I admit, but the question remains a good one. Is the purpose of flying catfish around the country to bring something from the wet world into the dry land, making the most ordinary thing on earth seem exotic by displacement? A catfish in the mountain west is certainly a surprise. Its incongruity, which seemed to me funny (humor often results from surprising incongruity), must create for others the kind of enjoyment I get when I spot a bird out of its range or locate a scene of natural beauty in a suburban backyard.

The surprise in the virtual place often involves an experience of some other place "as if you were really there."

To eat "fresh" catfish in Taos is tantamount to going wherever your desire may take you. I might desire a catfish, or a mango, or a chestnut when the only things available locally are trout, prickly pear, and piñon nuts. In this sense, going to any U.S. supermarket is to experience virtuality. Going to the farmers' market and buying local are merely artificial (agriculture being one of the first acts of artifice, the making of gardens and orchards and the breeding of animals for food in a place that was once different from what the farm requires—a forest rather than a cultivated field, an open prairie rather than a fenced pasture and hay barn). Fishing, hunting, and gathering would be natural ways of living in place, but they do not always satisfy the characteristic (natural?) human desire for surprise and variety. Before the success of the artificial and virtual, before agriculture made food more available and reliable in a single place, and before supermarketing brought the resources of the whole world into the neighborhood of the affluent modern consumer, the human desire for surprise and variety must have driven a restless nomadic wandering that required an enormous physical range. Wanderlust competed with the nesting instinct in the human spirit.

Today, when we grow bored with our hometowns and don't have the funds or freedom for world travel, wanderlust takes us to the beach. When Galveston doesn't comfortably or fully deliver the surprise and innovation at the rate required by expectations honed on the Animal Planet and Discovery channels, wanderlust drives us to the boat ride or amusement park. From there, we are drawn to Moody Gardens and the Rainforest Cafe for a virtual ex-

perience that resolves the old conflict between wanderlust and nesting. Such a place offers the comfort of home (temperature control and other protections from harsh weather, plenty of stored food on hand, familiar companions) and also, at a relatively low cost in money and effort, promises to satisfy the old nomadic spirit with an abundance of exotic creatures and cultures, and the surprise and excitement of discovery and trading—at least in simulation.

What gets lost or cheated in this solution? Mainly the desire for the authentic experience, the true, the real, what Henry David Thoreau must have meant when he said he went to Walden Pond to push life into a corner and suck out the marrow of its bones—to eat it, taste it, feel it, smell

it, as well as see and hear it. Most people are willing to trade off authenticity because of its high cost in trouble and money and to settle for the accessible surprise and variety of the virtual. Kids certainly are willing, and so am I when I'm in the mood to live as the godchild of Disney. Then I am amused at the cleverness of the simulation, and, happily donning the 3-D spectacles, I enter the theater of virtuality.

I know it's the adult in me, even the grumpy old man, who wants to wait for the full experience of the natural, even a diminished version of it. To give up the birdwatching on a given day and enjoy the fog. To endure the muddy surf and persistent stink and wade waist-deep to see fish jumping on every side, pelicans crossing a sunset sky, and gulls calling on high. The child inside, impatient and ready for action, cries out for Moody Gardens.

My colleague told me of a memorable scene. She's walking on the west end of the seawall near Seventy-first Street where the signs point to Schlitterbahn and Moody Gardens. Cars turning that way are backed up for blocks while across the street the Gulf of Mexico breaks against the seawall, sending a refreshing spray into the air for any who would bother to enjoy it. But the seascape goes neglected by the cars, whose passengers are intent on Schlitterbahn.

Schlitterbahn—what a concept! Basically, it's a water-park, lots of big plastic tubes and slides with pools and ar-

tificial rivers flowing here and there, the currents produced by electric power. The genius of the original Schlitterbahn had something to do with its location. Built in New Braunfels, Texas, a town originally settled by German immigrants in the nineteenth century, the old Schlitterbahn was situated in river country, where for decades (perhaps for eons) Central Texans have enjoyed the cooling waters of spring-fed rivers like the Guadalupe and Comal flowing out of the legendary Hill Country. The rivers are still packed in summer with tubes, canoes, kayaks, and practically anything that will augment the buoyancy of the overheated, overfed human body.

So Schlitterbahn was simply an artificial enhancement of a natural attraction. The names of the local rivers were invoked in rides and slides. At one place in the park, the artificial rivers opened out into a fenced-off section of the actual Comal, whose waters feed the plasticized streams of the attraction.

But it's the enhancements, not the brief moment of immersion in the natural medium, that have always been the draw. Instead of flowing peacefully down a slow river with the occasional fast slide over a low dam or shallow rapid, or swinging from a rope attached to a big cypress branch and splashing into a relatively deep pool of tea-colored water, you walk up narrow stairs some forty or fifty feet, to the very height of a healthy Texas cypress, then drop down a curvy plastic tunnel at high rates of speed and land like a rock skipping over a river in a clear and chlorinated pool at the bottom. People sit around in lawn chairs and study your face when you come up for air—will you

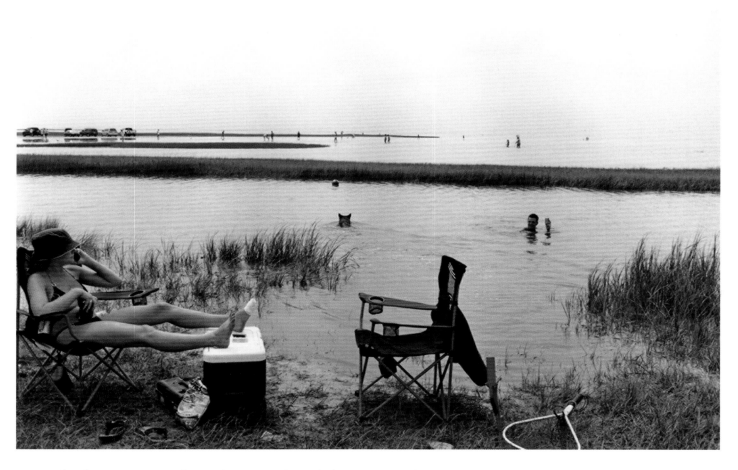

evince glee, horror, or mere discomfort? (It will surely be discomfort unless, as my experienced nephew once warned me, you keep your legs tightly pressed together during the full extent of the ride.)

With the higher thrill factor, ironically you get a higher measure of control. You avoid the occasional skid into icky mud. You don't have to worry about pulling up a frog, snake, or slimy water weed when you bring your hand out of the water to swat a mosquito. The experience is purified, abstracted, reduced to the essential elements of wet and wild without the messy details of the naturally wet and wild.

I'd like it myself if it weren't for the crowds. The heart-of-Texas version of Schlitterbahn packs full every summer day with people from all up and down the busiest traffic corridor in the state. New Braunfels sits right in the middle of the stretch of I-35 that runs from Austin to San Antonio, with Dallas to the north, Laredo to the south, Houston to the east. The dense population funnels in. You wait an hour for a one-minute plunge down a giant slide. Or you can bob along the "river" in a bright blue or yellow plastic doughnut (vaguely recalling the old truck or tractor inner tube that used to suffice on the natural river) with hundreds of other overweight tourists, propelled by the artificial currents that work like some liquid conveyer trafficking in sun-burnt human meat.

Just as crowded, and lacking its original point of reference, Schlitterbahn-Galveston forgoes the connection to the local landscape altogether, with the possible exception of a wave pool. The attraction is transplanted from river country, weakly translated and marketed on reputation alone. It's just the big Texas version of the waterpark you can find at any beach location in the United States.

Why do people abandon surf and sand for plastic and chlorine? For the same reason they neglect the natural river and favor the artificial: enhanced thrills and controlled environment. The kids love it, and so do mom and dad. They don't have to worry about jellyfish stings or shark bites and family members being swept away by rip tides in the oily waves of the Gulf. The marketers love it too, and along with them, everyone who wants to make Galveston a far-reaching tourist destination and not just a local getaway for hot Houston day-trippers. What's not to love?

In the early years of my disaffection with Galveston, it wasn't the shiny attractions and fine hotels that brought me back. It was the birds.

A chance drive back to town from the state park one day led me down Stewart Road by the dark-watered lagoons of natural Galveston, the open fields of spartina grass and bushy bluestem, wildflowers and high-tide shrubs, the openings out to the bay—rich marshy conditions that spell good habitat for hundreds of species. And there they were: every variety of southern egret and heron,

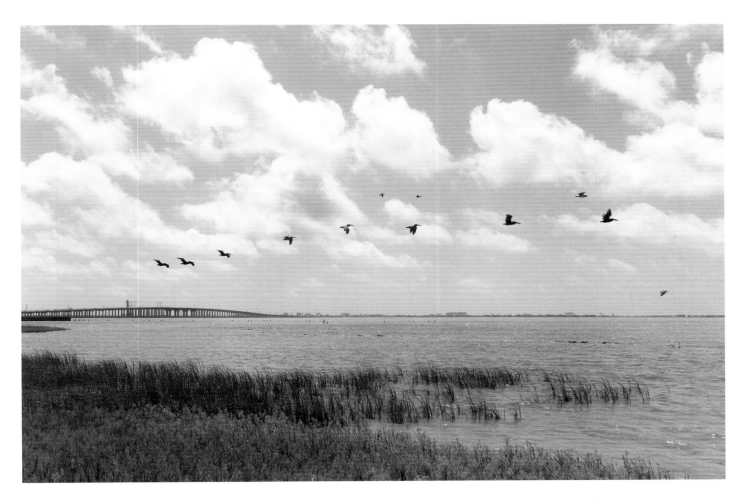

cuneiform ibises both white and glossy, ducks and stilts and roseate spoonbills, white-tailed kites and low-swooping harrier hawks, wintering sandhill cranes and kingfishers crying out the good fortune for all who would feed in this place.

The birds of the Galveston marshes brought back memories of family vacations to the Carolina coast in the 1960s, the time when, propelled by boredom, I first became a birdwatcher. It was during my preteen years, with puberty setting in—about the time that social life began to

mean more than anything else—that my parents began to insist that I abandon my friends every summer and travel with them and my irritating little sisters and brother to a deserted island. That's what Hilton Head felt like before the developers took over. Back in the sixties, you got to the island by crossing a rusty old bridge. There were long stretches of beach and marshland where you could spend a whole day walking or sunning or fishing and not see another person. We went every summer for years.

At first, it seemed there was nothing much for me to do. Without my friends, I quickly grew lonely and bored, and was pretty surly to my family, I suppose. At any rate, they never complained when I drifted off by myself along the broad hard beaches of golden sand, or took my bicycle out to the marshland paths, or walked the trails in the woods of live oak and pine.

Gradually the birds appeared. Brown pelicans cruised in squadrons low across the surf, folding their wings and dropping head-first into schools of fish just beyond the breakers. The gray-brown osprey swept into the water with its eagle's talons, bringing out a fish so big it could barely fly back to feed its nested young. Little plovers skittered along the beach in numbers I would never see in later years. Vireos and warblers materialized in the brush, shy exposures of bright yellow and blue-gray. The pileated woodpecker broke the still air of the pine woods with a wild cry in flight across a clearing with its big black-and-white wings and bright red crest.

Back then, the birds carried me away from my boredom. Later, they brought me back to Galveston, where

only rain and fog can spoil a good day of birding. I've never failed to see something interesting when the weather permits. I have to wonder how all those kids at Schlitterbahn and the Rainforest Cafe would respond if left to their own devices for days at a time, deprived of diversions and electronic stimulation. I have to hope they would find the birds and be rescued rather than stay lonely and bored.

The Age of Hooterization

Beneath all the layers of Galveston—natural, artificial, and virtual—is real nature, not so much the birds and the beach as the process of change itself: the decay, the funk, the corruption and rot of time in passage. The funky side of Galveston was never anywhere more evident than in a place I got interested in a few years back: the Balinese Room, a shabby beach bar built on a decrepit pier in the center of the famous seawall.

However embarrassed or amused the city fathers and mothers may have been about the Balinese, it had a special appeal to a connoisseur of place, especially an outsider like me, with the end of my own middle age just around the corner. The first time I saw it, I realized the link between places like the Balinese and my own fast-aging generation, born in the mid-twentieth century, lingering into the present but haunted by the past, crammed with old stories, buffeted by the forces of nature and tides of historical change.

The Balinese had somehow survived the forces of hu-

man history, though when I first discovered the place, a huge "For Sale or Lease" sign adorned its ancient side-timbers, hinting at a tentative claim on the future. "Welcome to the historic Balinese Room," said a cardboard poster in the front window, hand-printed in multicolored magic marker as if by a drunken grade-school child. It stood in contrast to a more legitimate sign of validity—a bronzed metal marker allegedly posted by the Department of the Interior that claimed the Balinese for the National Register of Historic Places. If the plaque spoke true, then because of its past, the future of the place had the warranty of the federal government.

I wondered. The paint on the pagoda façade was fading in the salt air. The sea lapped and tugged at the barnacled pier. I imagined that the elders ensconced in the Methodist home down the street, or the old families with a notion of historical preservation shaped by middle-class respectability, would just as soon have forgotten the shady past and seedy present of the Balinese. The surfing and skating youth, the bicycle-straddling thirty-somethings, and joggers with big-wheeled baby carriages would probably have had no trouble ignoring it, looking the other way, sick and tired as they profess to be of baby boomer nostalgia. The place was hardly ever open anyway.

But when it caught my eye a few years ago, I felt something like delight as recognition dawned, and interest took root. I recalled going to a ZZ Top concert back in the seventies when I was a college student in Tennessee, just about the time the band released the hit album *Fandango!* which contained their tribute "Balinese." I liked the song

for its wailing guitar and vocals, though I had no idea what the lyrics referred to, something about a crowded island in the Gulf of Mexico and a dancing girl named Ruby. Standing on the seawall that day, some thirty years later, the bright sun glinting off the pagoda and causing the mountain of garbage bags piled up by the front door to start to stink in earnest, I heard the chorus of the old song playing in my memory. "Down at the Balinese." I finally got it. Back at home, Jackie downloaded a copy of the song for me. There was a picture of the album on the iTunes site. The guitarist Billy Gibbons wore his white suit with a big red map of Texas embroidered on the back. In the seventies, Texas was a mystery to me, but with ZZ Top advertised as "that little ol' band from Texas," the state's coolness quotient went way up.

By the time I first heard the song, the glory days of the Balinese were already over. The lyrics hearkened back a decade or so—to the time when Jim Webb was writing the Galveston song that became a hit for Glen Campbell, about a Vietnam-era soldier longing for home and girlfriend, cleaning his gun and dreaming of a rather abstracted Galveston (rhymes with "sun" and "gun"). In those days, from what I'm told, concert promoters would fence off sections of the beach and erect makeshift stages for the rock bands. Long-haired youth with oiled bodies and addled minds danced to primal drumming and screaming guitars for whole weekends at a time. No doubt many of the island-goers slaked their thirst at the Balinese and probably listened to a younger version of ZZ Top.

Go back another couple of decades or so, and the no-toriety of the place was even greater. Owned by island entrepreneur and immigrant success story Sam Maceo, it housed an illegal casino fronted by an exclusive dinner club and dance floor that brought the most famous comedy and musical acts of the forties and fifties to the Texas coast. In the "history room" of the Balinese (actually a long stretch of covered pier), which I visited in 2007, you could still see (in addition to a life-size mannequin of ZZ Top's Billy Gibbons with his long beard and Fender guitar) photographs of Bob Hope and Bing Crosby, Dean Martin and Tommy Dorsey. You could read the story of how the margarita was invented at the Balinese when the legendary jazz singer Peggy ("You Give Me Fever") Lee asked the bartender, Santos Cruz, to make her something new, something southwestern. Cruz substituted tequila for brandy in a drink known then as the "sidecar" and gave it the Spanish version of Peggy's name. Born of boredom at the Balinese, the margarita went on to become the most popular concoction of hard liquor in the state of Texas, if not all of North America.

Throughout the heyday of the Balinese in the fifties, Galveston balanced its reputation as a family getaway with something a little edgier. The tension remained well into the time of ZZ Top's tribute. My colleague at Texas A&M remembers taking his family to the beach in the late seventies and being stopped by the police while taking an unguided car tour of the ship docks on the East Bay side of the island one late afternoon. The officers warned him not to be in that place after dark. International ships would land at the dock, disgorging sailors who came ashore look-

ing for drink, drugs, and trouble. People disappeared and never showed up again.

The Balinese, its pier crumbling into the sea, its welcome sign like a crayon drawing your mother saved for you from childhood, kept the tension alive. It offered a colorful contrast with recent attempts to upgrade the built environment of Galvestonian tourism. A Hooters sports bar had gone up down the seawall. A big gift shop expanded and remodeled on Murdoch's Pier. Other entertainments made you wonder if Galveston was losing its distinctive character and becoming a generic resort.

Call it Hooterization. The same process is at work elsewhere. I've witnessed it from Sydney, Australia, to Fisherman's Wharf in San Francisco. But where it really stood out for me was Myrtle Beach, South Carolina, a place I've spent vacation time since I was a toddler. Myrtle Beach used to be a fashionable resort with entertainments for families, teenagers on the prowl, and college students alike. On the model of Atlantic City or Coney Island, it had an amusement park, dance pavilion, hot-dog stands, beer parlors, boardwalks, and big hotels as well as "affordable lodgings" ranging from flophouses to family motor inns. As the twentieth century wound down, the place became a shabbier memory of itself. One novelist called it the "Redneck Riviera." Visitors ranged from NASCAR fans and bikers to middle-agers like me who brought their kids to ride the roller coaster and get a sense of vacation life back in the day. It banked on kitsch and nostalgia.

On vacation to Pawley's Island in the summer of 2006, Jackie and I made a stop at Myrtle Beach because I heard the old pavilion, long ago converted to a games arcade, was closing its doors. It was to be demolished so the space could be used to build an expensive resort hotel like others rising along the beach in a burst of recent construction. A few blocks away was a new attraction, "Broadway on the Beach," a glorified shopping zone with a few rides and virtual reality arcades for the kids. It was all very crisp and clean, high-tech and postmodern. It felt like Disney World to me (and is practically interchangeable with the renovation of Kemah Pier on Galveston Bay back toward Houston). City police and rent-a-cops patrolled discreetly. There was no room for the old gaudiness and off-color T-shirt shops. People walked around in clothes that matched, not overstuffed bikinis and wet bathing suits with beer bellies hanging over straining buckles. The kids wore tastefully decorated flip-flops.

Aside from the not-so-subtle raising of the social standards for participation (and the cost), I guess I have no real problem with the changes, only a little tug of the heart-strings, admittedly nostalgic. In another fifty years, our kids will be taking the grandkids to these places gone to seed and will tell about the old days. Some new character will be emerging.

How does a place like Myrtle Beach or Galveston develop character, the special qualities by which we come to know it? The answer lies at the intersection of history and personal experience.

Lying on the edge of sleep in a motel near the beach, the waves breaking and the birds crying into the night, I have a vision of how, for me, the Balinese mixes natural, artificial, and virtual Galveston into a salty-sweet cocktail of history. Its floor shaped by the currents of the sea, outer boards rotting in the fog, nature infuses it. Built for one purpose, rebuilt for others, and finally repackaged for the sake of nostalgia, artifice is everywhere.

It has a measure of virtuality, too. When the place was built, the island of Bali suggested something exotic, attractive, rare, distant, slightly forbidden. It was the Hollywood version of the South Pacific, evoked in "Bali Hai" (a song in the *South Pacific* film of the 1950s and also the name of a cheap wine sold in the 1960s: I saw the movie; I drank the wine and lived to tell it).

The Balinese Room was the Rainforest Cafe of its day, but for adults, not kids. With its pagodalike façade in bright red and green and its fake tiki interior, it offered a portal into another world. When you went to the Balinese Room, you drove off of the Texas mainland, then stepped off the very island of Galveston, onto the long pier reaching out into Mother Ocean. You left behind the cares of the fathers, entered the land of forgetfulness and dreams, of music and low lights, the touch of hot bodies, the swish of bright silks and seersuckers, the surge and lethargy of the alcohol high, the allure of quick riches in the casino.

It may all have been fantasy and phoniness, but so what? It conformed to a space in the mind to which everyone longs to go. It was all about Desire.

The Dream of the Fathers

Across Seawall Boulevard from the Balinese pier stands the emblem of the fathers' world, the Hotel Galvez. An eighteenth-century Spanish surveyor, Don José de Evia, named the island for his patron, the viceroy of Mexico. After Place of Misfortune and Island of Snakes, among other labels lost to history, the one that stuck was Galveston, as if the place needed a family name to carry it into the future. The Hotel Galvez was built by the city fathers of the Progressive Era during a two-decade frenzy of artifice that followed the 1900 hurricane—practically in defiance of nature, a virtual fortress on a mighty foundation.

Before the great hurricane, Galveston still competed to be the largest and most prosperous city in Texas. Many

changes conspired to send the honor inland to Houston—above all, the oil rush and the consequent building of the Ship Channel, not to mention the advent of air conditioning that later made Houston livable if not comfortable as a national city of prominence. But the hurricane didn't help the case for Galveston's growth.

To counteract the damage done to public relations as well as to protect the physical being of the city, the seawall was designed and constructed, and was celebrated as one of the great engineering feats of the early twentieth century. It wasn't just a matter of laying stone and mortar and constructing the jetties and hauling big rocks for support as riprap. It also involved raising the elevation of the whole city, lifting the surviving buildings and filling in with tons of earth dug from a local lagoon to build the place up above the level at which flooding was likely to occur even in light storms.

The Hotel Galvez opened in 1911, with its 250 rooms all reserved in advance. It was viewed, according to historian David G. McComb, as a living monument to the "Galveston Spirit."

Almost a century later, in 2008, on a rare September weekend of fine weather—moderate temperatures and relatively low humidity with bright sunshine and light sea breezes—Jackie and I strapped our bicycles on the back of the car, drove to Galveston, and took a room at the Hotel Galvez. The plan was to imbibe the Spirit of Galveston with an informal survey of the city's built environment.

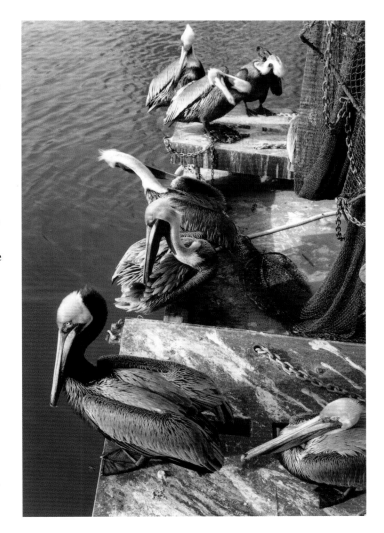

Saturday morning, September 6, I'm out at first light while Jackie sleeps comfortably in our elegant room. I walk east on the seawall, the city of Galveston with its famous old buildings off some twenty blocks to my left, the Gulf of Mexico to my right. I try to trace the line of demarcation between the natural and built environments, using the birds as a clue. The wild shorebirds—sandpipers, brown pelicans, what I think is a ruddy turnstone—yield the beach closest to the wall to the urban and suburban regulars: pigeons, great-tailed grackles, mockingbirds, and mourning doves. The raucous laughing gulls take up the challenge at every level—land, sky, and sea. An impressively large specimen of the Norway rat, with an ancestry that goes back to European sea travel, scampers out of the rock riprap at the foot of the seawall, then back to shelter after catching my eye.

The sun rises red but soon turns gold, and the landscape fairly gleams. Men in orange vests pick up trash on the beach. Black-eyed Susans cover the grassy, viney margin of land as the seawall turns away from the beach, hugging the outlines of the city protectively. Out of the exposed, wilder-looking land on the far east end beyond the beach attractions, a pair of white ibises emerges. A shrike calls loudly from atop a post, then flies off, on the hunt. An inca dove pecks like a chicken at the edge of the brush. We need to bring the bikes back this way this afternoon, I think, after we take care of business in town.

I turn and walk back fast, the wind at my back. I grab a cup of coffee as I pass through the lobby, go up to the room, and pull open the curtains so the morning sun over the Gulf can greet Jackie. She rises with a big smile as I sit down to write in my notebook at the window desk with the fifth-floor view of the Gulf. She comes over and looks out: the bluish sea; a shrimp boat from the Mosquito Fleet plowing the water, quite close to shore; the fishermen in the surf and on the jetties tugging at their lines, reeling in foot-longers that we see shining in the bright sun; two huge schools of bait fish (menhaden or other small fry) streaming by fast like dark clouds in the water of the seascape; the fins of dolphins rising and falling in pursuit—all framed by our view from the Galvez, below our window the hotel's green lawns immaculately trimmed and lined with palms.

"It looks like a tropical paradise from up here," Jackie says. Indeed it does—seen from on high, the perspective of the overlord. No rats or oily water spoil the vision. Trash collectors morph into beachcombers sauntering along. The bright sun purifies every little thing.

After a quick breakfast, we head downtown on the bikes. Cruising westward on Broadway, closer to the ground now, we get a mixed impression: on our right, the brick mansions of the founding families—Ashton, Sealy, Moody; on our left, across the median of the divided street, antique shops, dental clinic, acupuncture parlor, pawnshop, laundromat. In the median, the monuments to the past; on the sidewalks, the citizens of the present: a pair of black men in animated conversation, a woman dressed like a hooker, a cross-dressed homeless man with scruffy beard and cotton house dress, all emphatically urban.

We turn right toward the bay. At Twentieth-fifth and Market, we stop at Maceo's Spice and Imports shop. I'm

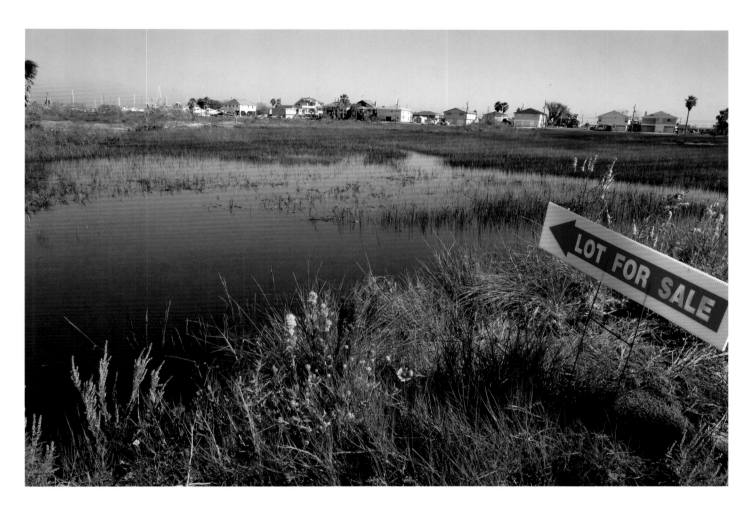

attracted by the name. I introduce myself to the shop-keeper, who turns out to be Ronnie Maceo, about my age. He tells me he went to school in our hometown, at Allen Academy, but has otherwise lived his life on Galveston. His father still comes to the store a couple of hours every day.

His son, who had been in the Marine Corps, has a beach concession providing umbrellas and chairs, jet skis and kayaks for tourists. The young man has a good deal, Mr. Maceo tells me, so he's not likely to keep the import grocery going another generation. The beach business is too

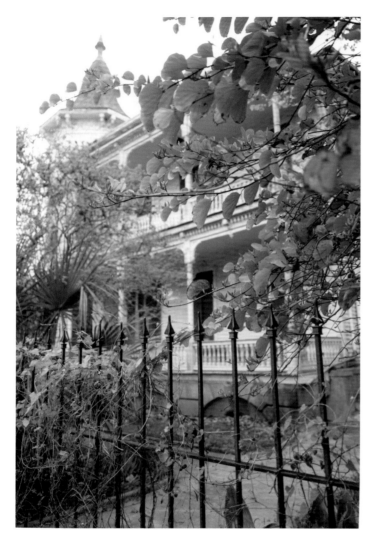

good; tourism is up. "The water in summer is better than it used to be," he says, "not as much tar. You used to get in, then come out with tar all over your legs."

I ask if he is related to Sam Maceo, who owned the Balinese back in its heyday. "My great uncle," he says.

"He was one of the city fathers, wasn't he?"

Mr. Maceo pauses and looks at the girl who works the cash register. She nods, and he says with an eye twinkle, "Well . . . we call them godfathers." After reflecting a bit, he goes on: "The guys from that generation were good people. They'd do anything for you."

The shop feels old-school and authentic, clean and cool. Mr. Maceo shows us the beautiful ravioli he's made for sale. We admire the range of Mediterranean and Caribbean spices. We buy dried cherries and Bulgarian eggplant spread. We say we'll be back next time in the car with a cooler to take home some ravioli.

We ride some more, up and down the boulevards, gazing at the old houses, architecture that has attracted the attention of so many Texas historians and historical preservationists. We can read the stories in the books, so we skip the paid tours; right now we want to get a feel for the place. To smell the old timbers and hear the stairs creak, touch the antique brick, and listen to the insects buzz in shrubbery planted by gardeners of generations past.

According to placards in the entranceway of the Moody Mansion, the huge brick dwelling at Broadway and Twenty-seventh Street, the first thought that Mrs. W. L. Moody had about the house after she heard that it survived the 1900 hurricane was that it would cost a fortune

to keep it up. But the Moody family had the fortune, and as the very embodiment of the Galveston Spirit, they had the will to buy the place, so it bears their name to this day. The family resided there until the last of them was urged away by damage from Hurricane Alicia in 1983. And that's the way it goes in Galveston: the spirit and will of the generations regenerate and erode with the coming and going of the hurricanes. The island marks its time and alters its character in two-decade intervals between the great storms.

Our thoughts run in harmony with those of old Mrs. Moody but apply to the whole of Galveston's built environment. We wonder how, even in times between hurricanes, they keep it all up as we cycle past structures of all kinds: mansions with carriage houses themselves designed by famous architects and fit for royal habitation; alleys packed with smart little dwellings once occupied by the servants of the big houses; quaint bungalows with low roofs and hurricane shutters closed up tight; sprawling two-story frame houses with galleries and porches that seem to cry out "more paint, please!"; old shops and storefronts and brick warehouses on city streets, the famous Strand mainly given over to the tourist trade, chocolate outlets, bars, and ice-cream parlors, generic businesses like Chico's and Starbucks, the corporate infusion of Hooterization; by the bay, the enormous cruise ship in the dock, the tourists spilling out on foot and riding those motorized Segues; some kind of oil-drilling vessel, equally gigantic (streams of mullet exploring the hull in oily water); the museum of the old offshore oil rig, the Ocean Star (big-seeming, but practically a miniature by current standards). Everywhere metal goes to rust, paint fades and chips and flies in the breeze, surfaces receive the white dung of seabirds whose calls fill the air incessantly, boards warp and crack as the wet air gives way today to the unexpected grace of a dry atmosphere. It is ninety degrees, yes, but something in the air suggests that summer will end, the season will change, the bright blue sky itself a sign that what is here today will be gone tomorrow. Not just historical preservation but all of human artifice works against the processes of nature and the test of time.

Emboldened by a refreshing lunch at the Mosquito Cafe, a snappy informal restaurant in what was once a nice little side-street house with a quaint courtyard, Jackie and I catch ourselves thinking we might like to live here. Then reality points to the endless painting, the vulnerability of pipes and plumbing, the life cycle of lumber. Salt air. Heat. Hurricane.

As if to escape the thoughts, we pedal faster back to the hotel, where everything seems in good repair. In relief, I enjoy a nap, exhausted from the very thought of all that upkeep.

Weekend in Paradise

Waking at midafternoon in the comfort of the Hotel Galvez, I think back to the time I lived in New Mexico. I bought a little brick house in a mini-development on the high plains desert in Socorro. The rainfall averaged seven inches a year, but the town was fed by a mountain spring that had flowed reliably since the era before the Spaniards came, for all of human memory, that is. The name of the town was tied to that spring. At the end of the long walk up the Rio Grande valley, you came to this place of "succor," where you could water and rest. The sky full of dry air nearly always shone as crystal blue as the sky I now see outside the window on this exceptional September day in Galveston.

I built a wooden screen porch on the back of the New Mexican bungalow, where, from my perch near the flood-control dikes at the foot of the mountain west of town, I

could watch the alpenglow in the evenings on the mesas across the Rio Grande valley to the east, the golden outline of cottonwoods in the fall, the green band of cultivated fields framed by red rock in spring and summer. I had the yard landscaped with rocks and pilings and native plants—piñon, greasewood, cactus, and one barrel-sized yucca palm. After that, I did nothing for five years—no yard work, no painting, only a little repair now and then on the swamp cooler mounted on the roof—and the property nearly doubled in value.

If neglected for a comparable time, the same house here in Galveston would be a ruin of brick in a jungle of native vines and shrubs. Wind and water would conspire to carry everything back to a primal, elemental state of being. I think of the photographs of Galveston after its many big storms, the piles of boards and building materials, people surveying the damage. And I think of what the photographs can't depict—the stench, the sound of wind whistling through the devastation, the buzz of the flies that fill the air, the scratch of rats and crabs running their missions of salvage beneath the heaps of debris.

But on this blessed day, a gentle breeze blows a benign spirit over the place. Hurricanes stay eastward and worry the coasts of Carolina and Florida. I get up and look out the hotel window. Beyond the muddy flats in the shallows, I see the Gulf stretch out blue and lightly rippled. A few fluffy clouds venture no closer than the farthest edge of the horizon.

At such moments, life seems to rest satisfied. Destruction and decay are banished to some comfortable distance. We call such moments paradise and strive with all our energy to extend them.

A couple of hours before sunset, we take the bikes down to the seawall and ride eastward, the way I'd gone on my morning walk. We plan to go as far as the wall will carry us. We pass Stewart Beach on our right, the scene of Jackie's childhood frolics, where it now costs eight dollars to park your car for the day, though free access to the beach is protected by state law. Like air and water, the beach is a common—like the old pastures at the center of agricultural communities, the village green, something to be shared by all rather than owned by a few. We stop at a bike shop and pay a dollar for air because one of Jackie's tires is low. Captured, usable air—like captured, potable water—has a price these days.

Eventually the seawall extends away from the beach, bending back around the northeast side of town between Galveston and the Bolivar Pass, through which ships move into Galveston Bay and head to port or, more likely these days, cross the bay toward the Houston Ship Channel. We stick to Seawall Boulevard, which leads to East Beach on the point of the island that fronts the Pass. On our side of the road, the seawall side, a stretch of marshy ground with numerous ponds and creeks intervenes between us and the development beachward—a nature preserve. On our left stands a levee like a wave of land maybe ten or fifteen feet higher, paved on the street side with a one-lane road on top, beyond which is more marshy land.

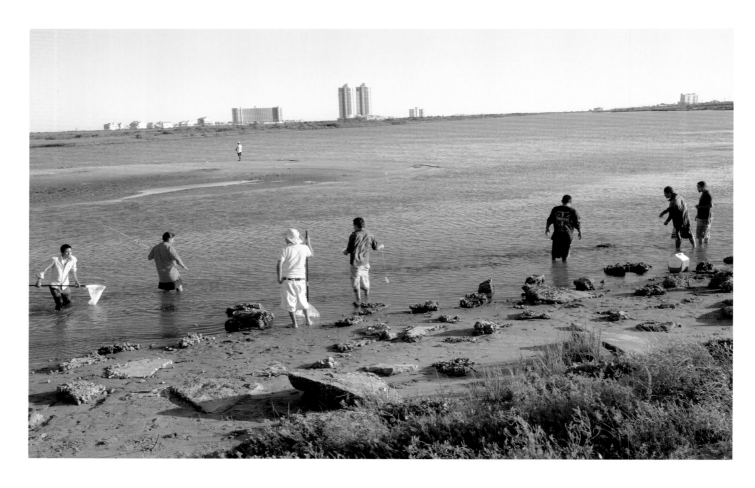

I've never seen so many white ibises as I see here—in all stages of development, from hatch year with mottled gray brown-and-white plumage that sets off the down-turned orange of the scimitar beak to full adults in stately white with black trim and red masks, as if ready for the grand ball. This marshy stretch of ground, only a couple of miles long and a few hundred yards wide, seems to be the nursery for the world's supply of these birds. And they're not alone. Herons and egrets of various species abound. We see a reddish egret repeating a ritual dance as it hunts, raising and quivering the wings before stabbing its beak like lightning into the water.

Schools of fish roil in the marshy ponds. They jump clear into the air, not once but twice or thrice like skipping stones. The egret seems to be using its wings to manipulate the shadows, confusing the fish about the direction of the attack. As we move on, Jackie signals to me to stop. "Watch the fish jump as our shadows cross the water," she says. We are riding up on the seawall with the setting sun off to the left, the lagoons below us on the right. As we move on, I watch our distended dark twins glide over the surface of the closest ponds, first Jackie's, then mine. The fish respond to hers with skips and leaps, settle down again, then re-agitate as my image goes by. She grins back at me over her shoulder.

We reach the end of the seawall and look out into Bolivar Pass. To our right lies East Beach ("Where drinking is legal," the sign says). I see a man fishing in the surf hook a big one and reel it in. He calls in Spanish to a young girl who wades out with a handle net. She holds the net at the surface of the water, and he takes the two-foot fish off the hook and drops it in the well she makes with the net. It would probably be too heavy for her to lift out of the water, but this way she can convey it to shore by pulling the handle along over the surface of the water, which stirs with the motion of the big fish. Two small boys, her brothers maybe, come over to admire the beast as she pulls it this way and that.

Our plan is to watch the birds at lagoon level by taking a trail we saw on the map. We ride down to East Beach and find the trailhead. Jackie follows it on her bike, which has trail-worthy tires, but I decide to walk and leave my trusty street cruiser with its balloon tires behind (a big thorn had given me a flat when I tried a trail back home in the Brazos Valley). I'm still locking the bike to the trail sign when back comes Jackie escorted by a black swarm. "Mosquitoes!" she says, but no need to say so—the evidence is all over her, clinging like a shadow. I hand her the bug spray from the pack, and she begins a liberal dousing, which sends them my way. We mount up quickly and fly for the main road. I've never seen her ride faster. We're still slapping mosquitoes as we climb up onto the level road and head back toward town into the setting sun, the breeze now saving us from having our arteries sucked dry.

With the wind at our backs and the sunset pinking the marshes, we regain our glow. To our left the distinctive clacking of the clapper rail begins—the bird that the old folks call the marsh hen, which I've watched with their broods of young every summer as long as I can remember in the marshes of South Carolina's Sea Islands.

We arrive back at the hotel as night falls and take the car to town. We enjoy a cheap meal in a tourist restaurant, then walk out on The Strand. In a small city park, they're showing an open-air film, *Casablanca* with Humphrey Bogart and Ingrid Bergman (banking on nostalgia again). As we're passing the hot-dog stand behind the viewers, Myrth calls from California. We take the cell phone over to a bench in front of the ice-cream parlor and sit talking, sharing the phone, enjoying a virtual reunion among the gas-lit storefronts and strolling couples. A history tour goes by on foot across the street.

Tuesday will be Myrth's birthday. It's been exactly eighteen years since the three of us first came to Galveston together. Back then, we would never have guessed that we could enjoy this place this much.

On this weekend of fine weather, even the Balinese seems to have improved and put on a new face. I look out on a sunny Sunday morning, from the lordly vantage of our Galvez window, and survey the complete length of its pier, from the pagoda façade at the sidewalk to the old ballroom at the end of the multiply propped, built-and-rebuilt structure. It seems solidly present, assertive even. The enormous "For Sale or Lease" sign I saw on the side of the pier last December is gone. Down at beach level, on my morning walk, I see that even the hand-printed welcome sign has been removed from the front entry, leaving the Department of the Interior plaque to proclaim historicity without irony. The piled-up garbage bags are nowhere to be seen, but a big mound of dog crap graces the sidewalk where the bags usually gather, the only obvious blemish on the distinct impression that things are looking up on Galveston's beachfront.

I am reminded by a historical marker only a stone's throw from the Balinese Room of something I read in McComb's history of Galveston: Henry M. Robert, one of the engineers in charge of building this seawall, was also the author of *Robert's Rules of Order*. Here's a classic case of a late nineteenth-century artificer doing his best to leave a legacy of order for the chaos that would become

the twentieth century, with its world wars, economic fluctuations, nuclear age, population explosions, galloping technological development, and environmental threats. In this seawall, and in the organization of meetings of social groups and corporate offices, Robert's legacy lives on into another century, along with that of his comrades, whose structures commemorate the human will not only to survive but to prosper with rational minds and a secure environment, nature (both human and nonhuman) tamed and restrained.

But no men of Robert's ilk—in fact no people at all— live in the grand houses we passed on Broadway yesterday. The Sealy house is owned and operated by the University of Texas Medical Branch. The Moody Mansion is a museum housing the eccentric collections of Native American arts and crafts, Christmas decorations, and furniture of Mary Moody Northen, the last member of the family to live there. After Hurricane Alicia drove her out, the house was restored and reopened to tourists. Like the outlandish showpieces of Navajo turquoise jewelry in the free gallery—far too heavy to wear—the house has become impractical for human habitation. Maybe it always was, at least without the most bracing infusion of Galveston Spirit.

And what of the seawall? It has certainly served its purpose—to protect against the tidal swells that accompany hurricanes—but in saving one aspect of the island, it has sacrificed others. The project raised the face of the island a defiant eighteen feet; and the land behind it as much, decreasing by one foot every fifteen hundred all through town, creating a drainage angle to prevent flooding. Additions to the wall extended it west along the waterfront, creating new possibilities for protected beachfront resort. By the time of Hurricane Carla in the early sixties, the wall was 10.4 miles long, covering one-third of the island's Gulf coastline. And yet, like all seawalls, it tends to encourage beach erosion. As the waves crash into the wall, they remove sand oceanward, which augments the natural trend of the sea-island coast to migrate toward the mainland. You can see the results at the west end of the seawall, where the beach is significantly indented. To prevent erosion, groins were built along the beach, first of wood and later of granite, arms that reach out into the sea, perpendicular from the wall, to gather sand as it moves along the beach in the long-shore current and keep it in place. Now anglers can sit on the great granite blocks and extend their reach into the surf, no boat required, just as walkers, joggers, and bicyclists benefit from the seaside promenade created by the seawall. But as sand is retained on the east end of the island, the west end incurs losses. Without the groins, there would likely be no sand on the beach that brings the main tourist trade. Already there is none at the west end of the wall.

Why does it all seem so hopeless, fix one thing and break another? Because that is the nature of artifice. It cannot last. The demanding natural forces of Galveston only speed up the fated drama of human beings and their mortal designs. All of Galveston city is a built environment, even the beach itself and the very ground on which the buildings stand. As such, it remains what old Cabeza de Vaca called it: Island of Doom.

As I walk along the seawall with the sun on my skin and the breeze in my face, I catch myself singing Jim Webb's song "Galveston" under my breath. Some notes I found in a book of his music suggest that Webb had never been to Galveston when he wrote the song. It was another one of those evocative names on the U.S. road map that stimulated his imagination and set the scene for the dramatic monologues he created of memorable American characters: the soldier in Vietnam dreaming of his girl back in Galveston, the Wichita lineman listening for the voice of his true love singing in the wires, the forlorn lover heading out of LA in "By the Time I Get to Phoenix." Webb's songs had place names but weren't really about places; they were about feelings, above all about desire and loss, unfulfilled desire and inevitable loss. Maybe the loss of place even figured into the total sense of inevitable loss, an effect of urbanization and globalization. Webb appealed to the sentimental teens of the sixties, who could never get close enough to their lovers in the days just before the so-called sexual revolution. His songs appealed in much the same way that communication technology does today in the virtual reality industry of cell phones and Facebook. When friends are lacking nearby, a network of others awaits online.

In Webb's song, Galveston is a mental place for which the heart longs. It is a paradise of sea and sun and free-flying birds and girls with shining hair. Not the crowded island of ZZ Top's "Balinese," even less the place where you can get dirty by going swimming, where the town is declining into a memory of an almost-glorious past, where the beach is eroding and the bay polluted.

As the end of the nineteenth century approached, Galveston could console itself about failing to be the most populous city in Texas by its claim to be the richest. It was known as the Wall Street of the Southwest. But the dream of wealth and a life of ease also proved to be primarily mental, a fantasy of the Galveston Spirit. Competition inland, changes in the shipping trade and the railroads, and much else contributed to the loss of this reputation. Stability, the hallmark of a strong financial system, eluded Galveston, with its natural profile of migrating sands, rising water, and high winds. It brings to mind the warning of the Christian gospels to build on solid rock rather than shifting sands or the myth of Icarus, who made waxen wings to fly to the sun. At least one of the three little pigs in the children's story was smart enough to resist the wolf with a brick house, but in Galveston, the wolfish winds blow down even the brick mansions of the smartest investors.

Instead of following the wise ants inland to places like Houston and Dallas, the people danced like the fabled grasshopper in the face of natural disaster. The orchestra played all day at the new Hotel Galvez during the 1915 storm. Dancing, some people said, would ease the ladies' hysteria as the wind gathered force and huge waves crashed against the still-untested seawall. The band played on, and the wall held firm.

Hurricane

"Death come a-howlin' on the ocean," says the old song "Galveston Flood," "and when death calls, you got to go." It might as well say, "Nature come howling on the ocean"— not as poetic, but just as true. If you want to see nature in a place like Galveston, don't look to the landscape, which can be reimagined and rebuilt. Look to the swelling waters and rising winds of the hurricane, a force that eludes human control and challenges the imagination with its devastating power. The histories, no matter how detailed their stories, the old photographs and film footage you can see on public television or in the Great Storm Theater on Pier 21, all the numbers and lists of the dead and the places destroyed—nothing can prepare you for the power.

When the hurricane came this time around, I thought I was prepared by all I'd learned about Galveston, but I had another lesson in store. It was about the limits nature can impose on a place and its people—and about the fate of places and people everywhere.

Friday, September 12, 2008, only seven days after our perfect-weather weekend at Galveston, I was back in College Station with a day off. The university was closed along with the local schools. A Category 2 hurricane named Ike was heading our way via Galveston and Houston.

On my walk that morning, the air was breezy, the clouds swirling, but otherwise things were nice. Canceling school would have seemed a serious overreaction except that the university and emergency community, remembering Hurricane Katrina, were preparing for evacuees. The first wave of them had already arrived from the coast. I saw migrants from the coastal bird community, too, along the little sandbars that form in the culverted creek in my neighborhood park—a group of tiny sandpipers, the kind that birders call "peeps," either western, semipalmated, or least sandpipers.

The rest of the day I would "hunker down" (the phrase everybody uses during hurricanes and bad weather around here) and stick close to my nesting place, watch the Weather Channel as long as the power stayed on, write in my notebook, and read a volume I'd been enjoying since my trip the weekend before: *The Formation and Future of the Upper Texas Coast* by the coastal geologist John B. Anderson, as much a prophet as he is a scientist, with his commentary on the creeping coastline and ill-fated efforts to protect beachfront property.

Only a week ago, Galveston was fresh and clear, a seeming paradise. Now Jackie and I watched TV in amazement as the tides climbed the top of the seawall and waves surged over. Places where we walked and watched birds were under water. As it was in 1900, the storm surge of Hurricane Ike was enormous, far greater than "Category 2" suggests. That rating mainly applies to the wind, which at that moment was blowing at a mere 105 miles per hour in Galveston.

Saturday, September 13, though I'd decided to sleep in, I was awakened at 6:30 AM by the sound of winds that seemed somehow distant. That's because I was sleeping on the south side of the house, and the early gusts come from the north. The eye of the storm was south and east of us, so that its northern arm circled back upon our town.

During the night, Hurricane Ike had blown straight through Galveston, crossed the bay, and was still raging at 100 miles per hour when it hit Houston. The TV said winds in College Station were about 35, gusting to 45. I couldn't imagine increasing this force by a factor of two or three. The trees in my yard were still standing, but their crowns blew southward. Still a Category 2 hurricane, the storm was centered between Conroe and Huntsville, proceeding right up Interstate 45 like some demon motorist. Another reason to be glad we don't have an interstate highway in the Brazos Valley, I joked to myself. We were on the far western reach of the storm, luckily opposite the mean northeastern edge and not threatened by the punishing eyewall to the south.

In Galveston, water was over the seawall in places, and much of the city a shallow lake. On the northwest bay near Clear Lake, where last spring we took my sister and dad to visit the NASA museum, sailboats from the marina were beached in parking lots. Windows were blown out of the Houston skyscrapers as they were during Hurricane Alicia in 1983. Three million souls had lost electric power. For the moment, our power was on, but the wind and rain were picking up.

I found a perch in what felt like a sanctuary—my screened-in, west-facing back porch, brick walls on two and a half sides protecting me from the swirling north wind and blowing rain. In front of me on the extra chair, the hairs on my propped-up legs lay flat and undisturbed. Ten feet away, on the back lawn, a tropical storm played havoc with the fans of the Mexican palms, which clapped together with surprising loudness. The neighbors' cypress tree and elms over the back fence bent away from the wind. The weeping willow threw its arms high into the air, as if to beseech the heavens. The rain didn't fall so much as skim in sheets along the landscape. Drops were hitting the ground, for puddles were forming, but I don't know how. The wind sang in the tree branches and began to howl in the distance. The meaning of the word *squall* as a noun and verb became real for me, the sound of the word perfectly suited to the meaning. The blue jay made what Jackie calls its submarine sound, a plaintive whistle in some forlorn nest nearby. It was the only sound besides the wind.

On Saturday at 10:00 AM, Ike's western arm fell upon us, the eye almost due east, now degraded to Category 1, but still a hurricane more than one hundred miles inland. We started to get some serious rain accumulation. The wind shifted and came from the south. In front of the house, it blew sheets of rain northward up the center of the street while the gutters on either side carried streams of water six inches deep and four feet wide southward in the opposite direction. The water's contrary movement

dramatized the plight of the low-lying properties around Galveston Bay. Drenched and flooded by the northwest-trending storm when it first hits, they get the outflow from swollen rivers like the Trinity for the week that follows.

I donned my swim trunks and went out to feel the weather. The rain was cool but misty-fine. I thought it would rasp bare skin, but the gusts broke drops into droplets and droplets into mist. My trunks were barely damp for the first several minutes. I was joined in the backyard by a very wet mockingbird hunting in the small creek that formed by the fence. A female house finch and Carolina wren hopped around hungrily under cover of the shrubs like homeless waifs caught out in bad weather.

I thought of the people I heard about on the coast who chose to stick it out in places like Crystal Beach on the Bolivar Peninsula. At that moment, many were waiting to be rescued from the tops of structures on the verge of being carried away beneath them. After a mere ten minutes of exposure, I was chilled and uncomfortable in the 30-mile-per-hour wind. Those who waited did so in unimaginable conditions—many more hours in much higher winds and harder rains.

After a hot shower, I was glad to be back in my back-porch sanctuary. The winds increased and the rain intensified. A house sparrow sheltered by the palm in whose shade we usually hang the bird feeder. "Sorry, pal," I said out loud, my voice all but drowned out by the noise of the storm. We had to bring in the wrought iron hanger for the feeder to keep it from pulling up and becoming a missile propelled by the wind.

Later I went inside and found myself thumbing through the classic book of architectural history and photography, *The Galveston That Was*. I could hardly bear to think of the charming city where we walked in gas-lit streets a mere week ago, the remnants and restorations of the world represented in this book, now under four feet of water and raked to pieces by high winds. With its sensitive ecology and natural vulnerability, the Galveston that is will always be on the verge of becoming the Galveston that was.

It's true that every built environment is limited by its natural base. Even in the slower-changing desert world where I lived in New Mexico, people built what they called fifty-year ranches in the canyons. Every half century or so, when an unusually heavy rain would come, a flash flood would rush down the canyon and carry everything away. Living there, even for a time, was literally a calculated risk. Galveston, with the almost visible progress of rust and rot and the accelerated destruction of a hurricane every generation or so, is only a more dramatic, and tragic, instance of every human habitation.

As a naturalist, I should nod my head and accept the inevitability. Instead, on the day of the storm, I felt sad to the point of sentimentality. Clichés nagged at me as I thought of the Galveston Spirit eroding over time: paradise lost and in need of rebuilding only a week after it appeared before my eyes as a shining reality.

The wind and rain kept up all morning but was a little lighter by noon. Birds began to chirp in the trees. By then, the TV cameras had moved out into the streets of Galveston. The most disturbing sight in the morning's

coverage was the image of boulders from the riprap on the beach side of the seawall that had been washed onto Seawall Boulevard by the storm surge as if they were seashells or driftwood. The power was unthinkable.

On Sunday, September 13, I was out at 8:00 AM. The sun was shining again, the wind low. Small branches and twigs littered the suburban streets beneath the oaks (post, blackjack, water, red, and live oaks) of the savanna that is the natural terrain of the Brazos Valley. The winds of Hurricane Ike had performed a natural tree trimming.

The residents of the Methodist home in Galveston only a few blocks from the Balinese had been evacuated to the Brazos Valley, to the big church I sometimes attend, south on Highway 6. The church has the right kind of space for sheltering longer-term evacuees because one of its buildings used to be a mental-health facility. Members of the congregation helped tend to the needs of patients and staff, more than a hundred in all. Just beyond the reach of the coastal storms, College Station is a good place to stop on the evacuation route. Over at the university, the basketball arena was once again fitted out for short-term use, just as it was during Katrina.

The Galveston That Remains

By the Monday following the weekend of the hurricane, news of the devastation in Galveston began to come in. My home Internet was down on Saturday and Sunday as the storm passed through, so I couldn't check the online news till I found some free time in the office.

It was frustrating trying to get the virtual connection to Galveston that I really wanted. One characteristic of place, any place, is that once you begin to feel connected, to make it your own, the particulars become idiosyncratic. I wanted to know about the state park, Moody Gardens, the Balinese Room, the Hotel Galvez. But I couldn't control the cameras. I listened to people who know next to nothing about the history of the island—the natural or the human history—the likes of Geraldo, for goodness' sake—bearing witness to what they could see from vantages they had chosen, often for the convenience of their camera crews or for safety reasons. I had to watch men and women I don't know get blown around in the wind and rain and talk about the few things they happened to recognize. "Hooters just blew across the street," Geraldo said. Even the news was Hooterized.

Somewhat preferable were the photographs and films put up on the Web by amateurs, often locals, though they didn't necessarily see my Galveston either. Finally I came across a gallery of photos of destruction along the seawall. The Flagship Hotel on its big pier was separated from the island by a collapsed bridge. The angle of one photograph seemed to suggest indeed that the pier that held Hooters was gone, along with the older Murdoch's Pier with its gift shops of shells and trinkets. I was getting closer.

Then I found a caption that said "Balinese Room." A bearded man about my age (my alter ego?) was pawing

through a pile of rubble. I thought I recognized a piece of the old pagoda façade. I searched under the rubric "Balinese Room Hurricane Ike" and there it was: an AP feature broke the news—the Balinese is gone. I scanned through the brief history of the casino and the famous entertainers who played there, feeling alternately sad and resigned. After all, it was a minor miracle that the place survived Carla in '61 and Alicia in '83. I was lucky to get a glimpse into the club and its fabulous history, and now, as my daughter said to console me when I called to tell her, I

have the memory—our most primitive virtual reality. The Balinese lives on in my notebooks and essays, in the memories of everybody who tilted a margarita back in the beach bar or danced on the surf-sculpted floor of the ballroom, in the history books, and in photographs by people like Geoff Winningham.

It was only a couple of weeks before Hurricane Ike that Geoff agreed to work with me on my Galveston project. I sent him some draft notes on the project. He read the manuscript and began to see the possibilities for photographic accompaniment. He seemed to like the tone, too. He called and asked with a laugh, "Why *would* anyone put a catfish on an airplane?"

I met Geoff when he was Myrth's professor at Rice University, and I had long admired his work. We both spent time in Tennessee in our earlier lives and had adopted Texas as our home. He read *The Galveston That Was* back in the 1960s when he was a student himself and began right then to photograph the city and has never really stopped. The place drew him in, as it did me.

He was finishing up a book on the Gulf coast in Texas and Mexico when I invited him to join the project, so he didn't have much time to begin work right away. With decades worth of familiarity with Galveston, he knew well enough to worry about the vulnerability of sites like the Balinese and was able to put in a little time before Ike struck. The very weekend that Jackie and I were biking around the city, he was, without our knowledge, on the island too, making some fine shots of East Beach and the seawall area, including the Balinese.

After Ike, he got back onto the island before I was able to break away (and before I could bring myself to go look on my own). On October 3, he phoned me at my office. "I'm calling from the seawall," he said. "I want you to know that Galveston has definitely been de-Hooterized."

Geoff saw a Weather Channel crew—whose footage I'd been watching for weeks—filming a commentator speaking into a microphone on the seawall. The speaker stood in front of an artfully arranged pile of detritus, which the camera crew had set up like a little still life before taking the shot. Global economy may have suffered a setback with de-Hooterization, but the work of virtuality was trying to keep pace.

All that was left of the Balinese, Geoff told me, was "an impressive ruin." He got a good picture of the pier's remains with big birds perched on the broken pilings. Nature had reclaimed the place at last.

A day or so later, I'm sitting behind Jackie as she enters "Galveston, TX" on the search bar in the computer program Google Earth. From virtual outer space, we home in on a rotating globe, arriving at an aerial view of the narrow barrier island not far from Houston on the Gulf coast. Jackie manipulates some buttons, and we drop in closer, arriving finally at a photographic virtual reality that looks much like the place we saw on our last visit before the hurricane.

We fly over the Flagship Hotel on its sturdy pier and land on Seawall Boulevard. Just to our left are the fine lawns of the Hotel Galvez. To our right, as we turn in ro-

botic sequence, we face the pagoda façade of the Balinese Room, a portal to a world that is no more. In a few weeks, or whenever Google catches up, the Balinese will be gone even from this virtual Galveston.

The truth dawns that only rubble really remains, fragments of lumber gaily painted red and green and gold. Left to the tide, it will become driftwood in the circulating currents of the Gulf. It will collect on a southwestward trash heap, perhaps at San Luis Pass or on the National Seashore at Padre Island. The wood will weather and make a home for crabs, sand fleas, and rattlesnakes. Raccoons will paw it over, in search of an evening meal. The fingers of the tides will reach for it greedily as the harvest moon waxes full and autumn hurries on.

The Return

On January 5, 2009, when Jackie and I finally got up the nerve to return to Galveston, we felt something like the shock of seeing an old friend devastated by sudden disease and rapid decline. We drove in from I-10, by way of the Bolivar Peninsula. At the exit for Texas Highway 124, the first signs that we had entered the path of Hurricane Ike were literally signs—the big ones along the interstate advertising Shell gas and McDonald's hamburgers in matching red and yellow. Still cracked and ragged after nearly four months, they looked like they had been shot out by howitzers.

Heading south on 124, we saw the ubiquitous blue tarps where roofs had blown away. Enormous heaps of debris appeared on the outskirts of Winnie—uprooted trees and broken branches together with building materials: drywall, siding, broken lumber, wires in a thousand tangles, insulated water heaters, and plumbing of all kinds. The piles of tree parts increased south of town. A bulldozer with a front-end chipper blasted away at a mound ten feet high and at least a hundred yards long by the roadside. The old telephone poles and service lines on the right side of the road were snapped and twisted, replaced on the left side by an entirely new set. Power was lost for weeks after Ike came through.

We passed through the village of High Island, the highest point along Galveston Bay and descended onto the narrow neck of the Bolivar Peninsula. What had been Crystal Beach and other small vacation communities lay devastated before our eyes. "I had no idea," Jackie kept saying. We looked for the house we once rented here but could not find enough landmarks left to identify the road it was on. Most dwellings were swept away or reduced to rubble that lay in piles as high as houses. A few of the better-built beach houses had been merely split open, the remaining rooms exposed to view like a child's dollhouse. Bulldozers and dump trucks from Houston ground away at their work. Debris hung on broken fences and trees; bed sheets and house curtains and white plastic snagged everywhere and flapped in the winter wind. In some spots, the beach on our left had already claimed the property of many homeowners—by law the beach is public land, so when the shoreline advances, beachfront lots disappear

and deeds go bad—and now the hungry surf reached for the reopened road over low flat land.

We passed the new school that had survived quite well, built like a concrete bunker on relatively high ground, then followed a yellow school bus leaking children into devastated neighborhoods, parents often waiting in cars to pick them up. And finally we passed the old lighthouse that has withstood so many storms, including the one of 1900. We drove aboard the ferry that would take us across the Bolivar Pass to Galveston, sharing space with dump trucks and after-school traffic. As the boat set off, we got out to feel the bracing wind, watch the pelicans brown and white, dolphins rising near the bulwarks as we departed, taking heart best we could, stunned by the reality of Ike's power, still so strongly evident these four months later.

It's going to be a long time before normality returns to the Bolivar Peninsula, if ever. Friends from College Station with family ties in Winnie told us that farming and grazing were all but out of the question for another season at least. The flooding from the hurricane salted the fields, and with drought conditions for months afterward, no rain had come to wash the land clean or at least dilute the salt. Along with the cattle, the wildlife suffered. With higher salinity in the water of Galveston Bay, beds of bay oysters died, and according to one account, snakes and alligators in the Anahuac National Wildlife Refuge were blinded. Alligators can't process salt as well as their cousins the crocodiles, so they can dehydrate quickly (though they probably die before going blind, the best sources tell

us). Our friends from Winnie saw two dead alligators in the Anahuac when they finally got the heart to pay a visit in early March 2009.

We check in at the Hotel Galvez with an hour of dim light left in the short January day, staying in the same room we occupied last September, the week before Hurricane Ike. From the window of room 540, where last time we saw thriving businesses on the beach side of the seawall, we now survey the ruined piers and blasted boards of Murdoch's gift shop, the broken pilings of the Balinese like random sticks protruding from the surf. The Gulf stretches out in shades of winter gray and disappears into a distant fog bank that melds with a low overcast sky.

We quickly go out for a closer look. A cool mist falls, the fogged-in horizon on every side lending a surrealistic feel, the margins of vision obscured as surely as the old landmarks are obliterated. Walking down the seawall, we see the damaged remains of Murdoch's Pier, the tatters of the gift shop left from the hurricane's explosive winds, its cargo of shells and trinkets spilled and now long gone, scattered to the four winds, or collected as trash or storm souvenirs. (A story I saw in the newspaper played on cheap irony by running a photograph of a man who had plucked from the rubble a painted board that read, "There's never a bad day at the beach." The people at the Texas Flight Museum sold muddy T-shirts as "hurricane shirts" to souvenir seekers. "I wish we had more of them," they told our friend.)

We see dents in the sidewalk on the top of the seawall

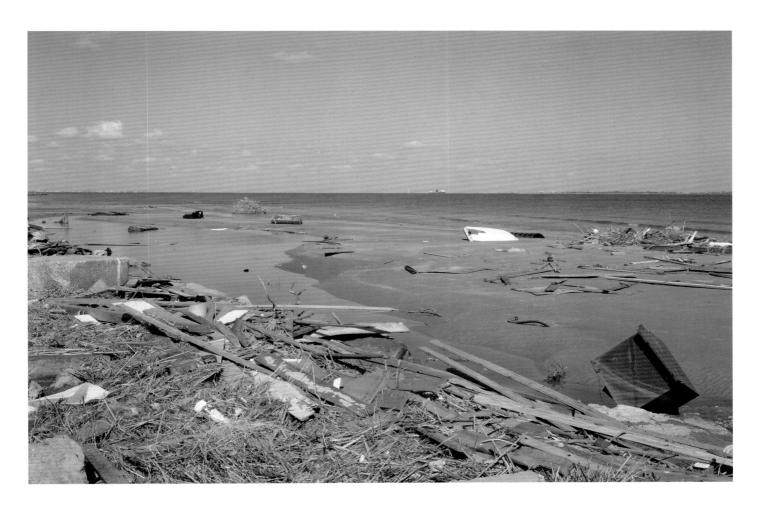

where the boulders from the riprap were carried over by the storm surge. Damaged segments of the walkway are marked by sawhorses and orange plastic tape, the kind you see at a crime scene. Beneath the broken concrete, fill dirt is revealed, sand and refuse a century old. We see the dam-age to the Flagship Hotel, out on the only pier that seems to have survived intact, though it is more thoroughly banged-up than the pictures on the Web and TV revealed. The driveways onto the big pier are caved in; a few aban-doned cars out by the hotel sit rusting in the drizzle,

months ago no doubt declared "totaled" by the insurance companies. One of the two huge mermaid figures in the side panel of the hotel is broken in half. It seems significant, spooky even, that the human portion has been blown away, leaving only the bottom with the tail of a fish. The other mermaid stares at the empty space where her sister's head had been. She poses with the back of one hand against her forehead, the head tilted slightly upward—a gesture that must have originally suggested seductiveness but now appears as the classic posture of grief or woe you used to see in the old melodramas.

On the way back to the hotel, we linger at the ruin of the Balinese pier. At the place where the entrance had been, somebody has erected a simple portal of the old tim-

bers, repainted and affixed to the sidewalk, the style hinting at the old pagoda of the club's façade. The only identifying sign on the little monument is the metal plaque rescued from the destruction (perhaps by the bearded man I saw in the Web photos pawing through the rubble on the day after the storm). With consummate irony, it declares that this site is listed on the National Register of Historic Places by the U.S. Department of the Interior. Look into the portal, and you see nothing but the splintered pilings of the ruined pier and the Gulf of Mexico stretching to the gray horizon.

The morning of January 6, I walk out into a dim gray light at 7:30 AM. Rush hour has begun in Galveston on this Thursday morning, and every third vehicle or so is a big dump truck. The hauling business in Houston appears to be thriving despite the bad economy. No one is on the beach this drizzly winter morning, though a few like me are going for morning walks on the seawall.

I take the same route I took in September the week before Ike, eastward toward Stewart Beach. Everything on the beach side of the seawall in this direction is also destroyed or badly damaged. The ubiquitous heaps of rubble appear every twenty yards or so. I see a largish sandpiper and a smaller one, but the gulls hold sway—the vultures of the coastline, with plenty to keep them busy. I walk past the barrier onto Stewart Beach, where workers are erecting fence posts at regular intervals. The concrete-and-steel booth at the parking lot where last summer people paid to park their cars and enjoy the public beach is cracked open like a seashell tossed by the surf. The old gift shop is typi-

cal of the structures I see. The walls still stand, but the windows, floor, and ceiling are blown out as if by an explosion, the roof caved in.

I go back up to the seawall and keep moving eastward, the space between me and the surf widening. The big trucks go by with a roar, spewing diesel fumes, driven by the latest infusion of Galveston Spirit. With a burst of energy myself, I speed up, the mist stinging my face. The Spirit will have to be strong to clean up this mess, I think. Three months have passed, and the place is still a wreck. A few sites seem to concentrate energy, building toward the tourist season in spring and summer, such as the high-rise condominium complex out there beyond the marsh on the beach to the east. Truck after truck heads that way.

To my left, the side of the boulevard protected by the seawall, a number of businesses have reopened, but many still have that blown out and partially collapsed look. I've heard people say that you can tell which places were well insured by this difference. To my right, the Sandpiper Motel, which looked so good back in September with a new coat of paint, sea-foam green, and a sign promising "an authentic beach-motel experience," retains its cheerful outer shell, but it's closed and clearly hurting on the inside. In the parking lot below the rooms up on their stilts over the beach, the entrails of flooring and wires are tellingly exposed.

The buildings look as if a whole generation has passed since the last time I saw them, without anyone's attention. Two decades worth of wind and water have sucked and strained the newness out of them, opened their skins to the elements. Letters are missing from signs, siding

and roofing broken and left in disarray—precisely like the abandoned parts of towns you see when the owners have let the places go to seed, awaiting buyers and investors or insurers that fail to show. The newest structures are billboards from realty companies, offering sites for sale. You can probably get a good deal on commercial property along this part of the seawall. Alongside the realty ads are big signs for law firms offering to help arrange fair insurance settlements.

I continue walking eastward until I come to the marsh preserve. Where the seawall bends toward town, I follow the dirt road leading down into the marsh. There's not a white ibis in sight, the bird that predominated here back in September. Every time I think I see one, it turns out to be a rag of white plastic. Where does it all come from? The stuff is everywhere. I think of the plastic islands I've read about—huge rafts of trash floating through the oceans, miles from shore. Made to resist the weathering power of nature, plastic succeeds with a vengeance.

The drizzle increases as I turn back. I'm pretty wet by the time I arrive at the Galvez. I see the renovations at work in the basement where the office and workout room used to be—presumably that level was flooded like other basements and parking garages even on the driest side of the seawall—though superficially all is well at this bastion of Galveston Spirit. The staff keeps smiling and greeting. The lobby is fine, the rooms as plush as ever. But the roof needs repair, and I can hear workers in the upper-story rooms as well, where windows are out and some damage obviously occurred.

As I suspect, Jackie has not been able to sleep through the banging and drilling up above our room. Now we know why the staff tried to put us down on the third floor when we asked for the same room we had in September. It's our own fault, but the noise drives us out. We were planning to stay another day, do some winter birdwatching, but the construction noise, the roar of the trucks on the boulevard, the drizzly gray of the atmosphere, and the sagging spirits in this time-warped town make us change our minds. We check out and head home.

But, as the signs on some of the wrecked businesses say, *we'll be back.*

Back to the Beach

On one Galveston weekend a couple of years ago, I ate too much of a good fish dinner at Gaido's and asked Jackie to take the car back to the motel so I could walk it off. I headed down the seawall, the Flagship Hotel in the near distance marking my progress over the twenty blocks or so.

Just as I was hitting my pace, I came upon a man seated on one of the seawall's concrete benches with his well-used bicycle leaning against him and in his hand an open beer can wrapped in a brown paper bag. He was about my age and had a white woolly beard like mine. He pointed to my face and pulled at his own beard. "These women won't give *us* the time of day, now will they?" He nodded down the beach, and I turned in time to see the shapely behinds of two dark-skinned girls receding in the distance.

"No?" I said.

"*Hell*, no," he said, then winked. "But we the ones who bring home the paychecks, now ain't that right?"

"It sure is," I said, moving on with what I hoped would pass for a knowing grin. Behind me, as I walked away, he said, "*Hell*, yes, damn right, it's the truth!"

Hitting my pace again and noticing the patina of trash along the beach side of the seawall, I got to thinking. Often, when people my age start bringing home the paychecks, they outgrow places like Galveston and set their sights on real tropical islands and famous foreign countries. They fly to Fiji, take cruises to Bermuda or Belize, gamble on the Riviera.

I keep coming back to these old haunts. I can't seem to let go. I guess it's because I have identity with these places, memories, stories, something like a spiritual connection. I am the toddler in the black-and-white snapshot at Myrtle Beach, covered with sand like a catfish coated with cornmeal and ready for the frying pan. I am the bored teenager on Hilton Head learning to watch birds, play the guitar, and read books to fill the long hours of family vacation. I am the young parent camping at the state park in the heat on a tight budget. I am the old man stopping on the seawall to talk about the fickle young women. For me, these places—Myrtle Beach, Hilton Head, Galveston—are the very setting of selfhood.

Going to the beach provides time and occasion to reflect on the condition of the self. One is exposed—age revealed so that even a passing stranger joins you in musing on the passage of time and the state of bodily existence. We wear

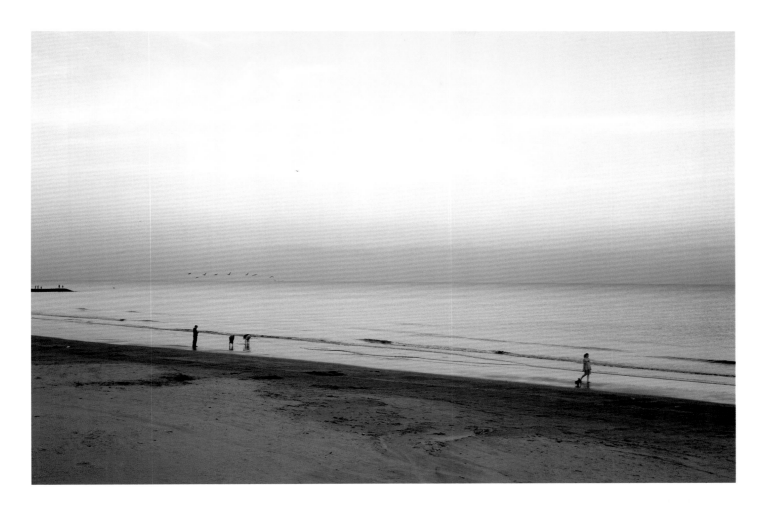

bathing suits, T-shirts, or no shirts at all. I wear shorts and sneakers and look only like any other old man with a woolly beard. I don't wear a jacket and tie and look like a professor.

 The history books tell how at the end of the nineteenth century in Galveston, in the years just before the great storm, sea-bathing in mixed company first became accepted. People didn't know what to wear. The bathing suit had not been invented. Newspapers and magazines gave instructions on how to make one for yourself, modifying a pattern for underwear, which was mainly long in those

days. Even to reveal the contours of the body by wearing clothes tight enough not to hamper swimming was shocking to some. The new fashion amounted to virtual nakedness in the days when both men and women wore elaborately layered clothing even in hot weather (though weather was cooler in the 1800s, when North America was coming out of a "little ice age"). Up to then, naked swimming was the norm and, except for scandalous exceptions, a same-sex event.

Since those seemingly more innocent times, people have gone to the beach to shed the daily artifice of their business clothes and return to a primitive state of relative undress. When I was in high school, all of us who could afford to and could get parental permission went to Myrtle Beach as soon as school was out for the summer. It was a more-or-less accepted ritual. Summer employers in the hometowns would even wait for kids to return from "first week" at the beach before starting the clock for summer jobs. Society seemed to acknowledge the need for a return to the primitive as a safety valve to release the pressure of youthful energy, sexual and otherwise. Girls tried out bikinis, and guys cut off their jeans and went shirtless and shoeless day and night. It was a risky (and risqué) interlude, but most of us survived to become teachers, doctors, bankers, lawyers, steady workers, responsible mothers and fathers.

Walking on the beach or swimming in the surf, skin exposed to the rasp of wind, salt of sea, and bright sun that adds color to even the whitest descendants of old Europe, something awakens inside, new thoughts churn, awareness blinks into life. Not just the perfect bodies you see in mag-

azines and on TV but also the fat, the bony, the hairy and disfigured, infant, young, mature, and old, parade around virtually naked. Humanity au naturel, digging in the sand like our simian ancestors, splashing in the water, basking in the sun, we live our animal life as we did for millennia. Human nature all but demands this occasional opening of the senses, clearing of the mind, returning to the lap of Mother Ocean.

"I hope you will all come to the beach this summer," the mayor of Galveston says, "and consider buying property and investing in our city." The mayor is promising that "shoreline protection" will be her leading priority.

I heard her speech in Houston on March 11, 2009, at a symposium called "Life after Ike" co-sponsored by *Texas Monthly* magazine at Rice University's James A. Baker III Institute for Public Policy. The other panel members certainly enlightened the audience with information and insights, but the rest were eclipsed by the presence of the Galveston mayor, Lyda Thomas, a living and relentless proponent of the Galveston Spirit, the granddaughter of city father Isaac H. Kempner (ironically known as "Ike"), who led the recovery from the storm of 1900 and was one of the original investors in the Hotel Galvez.

Mayor Thomas vented her frustration with the Texas Department of Transportation over delays in the rebuilding operation; with the federal government, which took more than six months to pay the bill for the tents the city put up for people injured or displaced by the storm and

signed for on the promise of payments from the feds; with the University of Texas Board of Regents, which until the very week of the meeting had been entertaining a plan to close the venerable medical school at Galveston, which had laid off hundreds of health personnel and other workers in the aftermath of the storm. Closing the school, everyone was saying, would drive the final nail into the coffin of Galveston's future. But now the school would reopen, the mayor announced with a tone of guarded but still triumphant hope. The city would retain this important keystone in its economy and, along with it, the medical facility that not only sustains community health but also provides emergency care in the island's "culture of preparedness" (as another panel member termed the new attitude of Gulf Coast Texans).

The note of triumph prevailed in her talk and never allowed the venting of frustrations to descend to whining complaint or the expression of grief over the loss of historical sites and the slowing of economic growth to overwhelm her unyielding belief in the future of Galveston. When asked by an audience member if it is wise social policy to keep trying to attract new development in a place so threatened by natural disaster, Mayor Thomas answered firmly but evenly, repeating her watchword of "shoreline protection." "We must make every effort," she said, "to protect [property owners] and their investment." And she unveiled plans for expanding the seawall.

She gave special emphasis to a design proposal known as the "Ike Dike"—a project clearly close to the mayor's heart and with a resonant name that commemorates her

grandfather as well as the current generation's storm and, for some of us, recalls the old story of the little Dutch boy who put his finger in the dike to prevent all Holland from being flooded. The brainchild of engineering professor William Merrell of the Texas A&M branch at Galveston, the Ike Dike would extend the seawall the full length of the island and the Bolivar Peninsula. Modeled on the giant structure that now protects the Netherlands from the cold waters of the North Sea, the Ike Dike would put gates at the entrance of the Ship Channel east of the island and at San Luis Pass west of the island to release floodwaters brought into the bay by storm surges. The project would cost somewhere in the range of two billion dollars, which supporters point out is roughly 10 percent of the cost to repair damage from the hurricane. Not only would it protect the historic city of Galveston and the vacation properties in the region; more significantly, in this era of homeland security, it could prevent flooding of the oil-production facilities that line the waterfronts of the Houston area. With a slight course adjustment, Ike could have landed there.

With current technologies, the cost, energy, and political will it would take to build the Ike Dike would make the project equivalent to the building of the original seawall in its time. For Galveston—and the whole bay region, including Houston, soon to become the third largest city in the nation—to survive a hurricane every generation may require a project of this magnitude at least once every century.

I'm eager to see how the mayor's plan for recovery is working out, so I take time during spring break to go to Galveston, though I have time only for an overnight visit. The sun is shining as we emerge from Houston traffic at midday on March 16, 2009, heading south over the last stretch of coastal plain before we reach the island. The air quality is poor, even after several good days of rain have brought some minor relief to what has been a fairly severe drought all across Texas. Our eyes water and sting as we walk along the seawall after lunch, the light cool breeze failing to dispel the bad air. The distant horizon is obscured by an LA-like brown haze.

As always, nature and humankind conspire to produce the smog. Trees are pollinating for spring, and the air is heavy with fog every morning, causing flights in and out of Houston to be delayed or canceled. The human contribution to the haze includes a by-product of the Galveston Spirit. Big diesel trucks and bulldozers are busy rebuilding the beach. We watch entranced as trucks dump load after load of nice new sand, beginning at the seawall and working down to the surf. At the symposium last week, the mayor explained that the new sand isn't just for the tourists—though tourism is crucial to the rebuilding of the city—it's also needed to fortify the seawall, which was undercut by the power of the storm surge.

Tourism right now is hurrying to keep up with the rebuilding of the beach. Despite the noise and the haze, spring-breakers spread blankets and picnics on the sand just west of the rebuilding operation and even dip into the

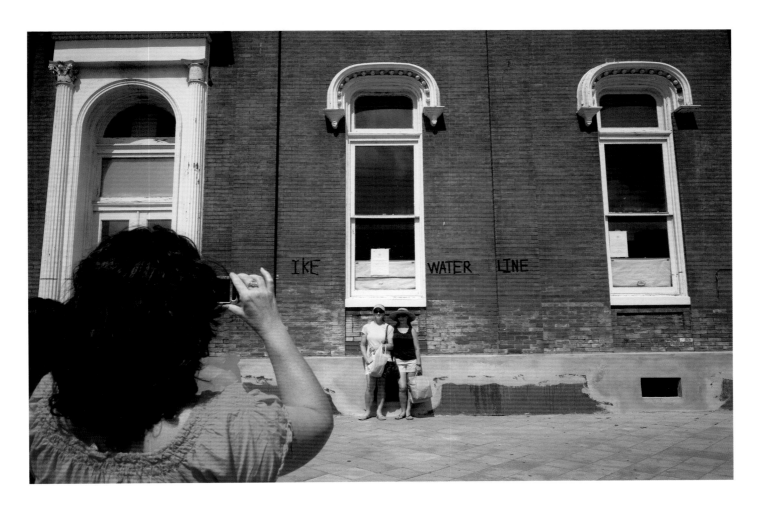

chilly surf. Nature returns immediately too. The surf eats away at the new bank of sand, leaving a steep little cliff about a foot tall at the edge of the water and cutting tiny rivulets into the new beach. The sand that the builders have brought in, despite their best efforts, is more loosely compacted than the old base. What the mayor calls shoreline protection will always prove a formidable task.

The tourist's Galveston is our Galveston more than it is the mayor's Galveston, I know. Paul Burka's *Texas Monthly* essay "My Frail Island" tells how tourism has

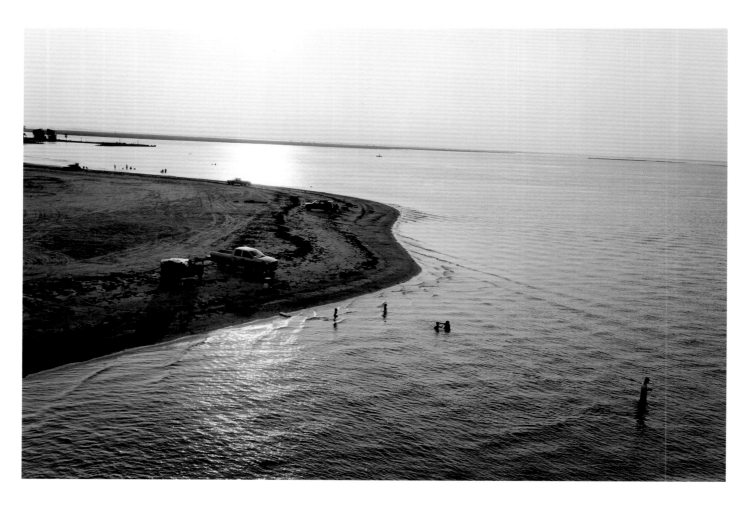

always been an irritation for the old families, some of whom make a point never to drive on Seawall Boulevard. They still tend to think of day-trippers from Houston's working classes as the primary source of tourists even though the island has recently become a "final destina-

tion" for travelers from greater distances. Recalling Jackie's family in the old days, I cringe to read the line that Burka repeats in his article: the locals used to say that visitors from Houston drive to the beaches "with a dirty shirt on their backs and a five-dollar bill in their pockets and never

change either one." Of course, locals everywhere complain about tourists even when they do contribute to the economy. A student of mine once saw a bumper sticker in Maine that said, "Next Time Just Send the Money."

As we watch the out-going traffic that evening, we surmise that much of the crowd has indeed come from local towns and cities, making the most of Galveston's recovery in hard economic times rather than making longer spring-break excursions to South Padre, Panama City, Daytona, or Fort Lauderdale. At dinner, though, we have to wait forty minutes to get a seat at Gaido's, and the next day, we find the parking lot full at Moody Gardens when we go to watch the new IMAX film on dolphins and whales.

After a good lunch at the Mosquito Café on the day of our departure, we drive around downtown to see how things are going. The Strand is making a comeback. Drinkers lounge in a few watering holes, doors and windows open to the cool breeze. About every second establishment shows signs of life. A blue line about five feet above the foundation on one brick wall is labeled "Ike's Water Level." The reality is stunning: six months ago, we would have had to swim through these streets.

A few blocks over, the recovery is not as strong. Maceo's Spice and Imports grocery has closed. We'll never be able to make good on our promise to come back and buy some of Ronnie Maceo's homemade ravioli. His retirement must have been accelerated by the storm. The name is still painted on the side wall, but the place stands empty, a "For Lease" sign in the window. The entire block of buildings there on Market Street is devastated.

Homing

May 18, 2009. I remember my friend's story about the line of traffic turning away from the Gulf toward Schlitterbahn as I go the opposite direction today, reaching the seawall on my morning walk after spending the night in the Moody Gardens Hotel. The sun is shining, the air a cool sixty-five degrees, the breeze coming off the water.

I've just passed a neighborhood that was surprised by Hurricane Ike. Feeling safe behind the seawall, where Carla and Alicia had reached them with wind but not water, they were not prepared for the mighty swells that came from the bay behind. Now, eight months later, old drywall and other building materials are piled on the curb or in temporary Dumpsters in the driveways of nearly every home. Little signs on the lawn give the names of construction companies doing the renovations. Some houses remain decrepit. Others are up for sale. Yard plants suffer from exposure to salt water.

Around the grounds of Moody Gardens, you can trace the level that the water rose by the absence of the once-thick ice plant, ground cover, and shrubbery that has been removed by landscapers after being ruined by salt water. The work of replanting is going on today. Across the street, Schlitterbahn, though damaged a great deal by wind and water, seems to be on the verge of reopening. I guess it's easier to repair plastic and concrete than to re-grow gardens and rebuild houses.

Last evening we visited the newly reopened bay side of the state park. The beachside camp is still closed; its al-

most new visitors' center was destroyed and is still gone. Back in March from the main road we'd seen people cleaning up debris along the bayside park roads. Now the place is beautiful again, but different. The nature-watching platforms, trails, bridges, and boardwalks are either unharmed or nicely repaired. It's the plants that show the effects. Some of the low shrubs seem to have died. They look burnt. In fact, the land looks as if it has been burned off and re-grown the way some farmers do with their fields—but again, it is the work of the salt from the bay floods. True to its popular name, the saltgrass (possibly smooth cordgrass) is fresh and green in a way I've never seen it here. Streams of cool breeze play through the new shade of light green.

An ibis flies by, lifting a hieroglyphic silhouette onto an old post. The shifting light of the cloudy May day reveals the bird's colors—white and black, with red mask. Among the ubiquitous laughing gulls, a pair of marsh hawks—northern harriers, the male silver, the female milk-chocolate brown—swoop low over the new grass and lush carpet of wildflowers (black-eyed Susan, yellow daisy, Indian blanket), then speed away on the rising wind, putting the distance of a football field between us and them in a matter of seconds.

On a lawn near the golf course, we spy a flock of some twenty white ibises, maybe the very ones missing from the marsh out toward East Beach, where the flapping white plastic replaced them in the wake of Ike. Unlike the variation we saw in their marshland nursery last fall, these are all adults. The regularity of their coloration and the incessant bobbing of their heads as they peck for grubs on the neatly mowed grass make them look comically artificial, like mechanical yard ornaments.

April 18, 2010. Another cycle of seasons has turned, our lives pressing on. This weekend, Myrth is visiting from out of town and goes to Galveston with Jackie and me. We're surprised to find it crowded—no rooms in the Galvez, a wine and food festival in progress, a senior prom at the Hotel San Luis. The official vacation season has not begun, Mardi Gras and spring break have passed, but the beachfront looks again like a tourist attraction, people buying shaved ice and riding in the pedaled surreys. Bicycles and walkers compete for space on the seawall. The fishing piers have yet to return, but the jetties are packed with anglers. Like the squadrons of pelicans landing in the surf only yards away from the western end of the seawall, the fishing folks seem to be enjoying an abundance of game: something's running out there. The Flagship Hotel is cleaned up but still unrepaired, its exposed interior walls now covered with graffiti. The obliteration of Hooters remains complete. But Murdoch's Pier has been rebuilt, looking remarkably as it did just before the hurricane, and customers swarm over the shelves of trinkets and seashells in the shop. The wood of the floor and walls still smells new. The paint is fresh on the big letters that proclaim "Family-Owned Since 1911." I see a copy of the painted board I saw the man carrying in the newspaper photo after Ike, now proclaiming without irony, "There's never a bad day at the beach."

On my seawall walk this morning, gray and cloudy at first light, I recalled that first winter after Ike, a memory with muted colors. The monotone of cloud and sea and broken board reminded me of the black-and-white photography and films of the old storms' destruction, the only variation in shades of gray. But today, as a rusty orange tractor with a front-end shovel and a rear-end raking device grooms the still-new sand of a rebuilt beach, an orange sun appears in a slit of cloud cover and spreads a bright streak across the eastern horizon ahead of me. Nearly the same color graced the throat of the tricolored heron Jackie and I saw last evening in the ditch by Sportsman Road—and under the chin and shading onto the breast of the barn swallows swooping out over the marsh from the eaves of rebuilt houses, leaving their fledglings on the fence to watch and learn how to feed on the wing.

The colors bring the place alive like a break in the sepia shades of a broken past. The beach is strewn with the purple-blue, transparent heads of the Portuguese man-of-war, many of them still alive, reaching upward, seeking the means of buoyancy on an unyielding stretch of gray-brown sand. Tentacles of bright teal lie threatening but inert alongside. Remembering a sting on a trip to Surfside Beach as a young girl, Myrth sidesteps a long blue strand with a little leap, then notices with a laugh that this one is a lost length of nylon cord. She points out another man-of-war that's clear instead of blue, and another with a coral-colored seam in its plastic-balloon-like head. The color matches the stem of a clot of seaweed to which it is attached and with which it made landfall.

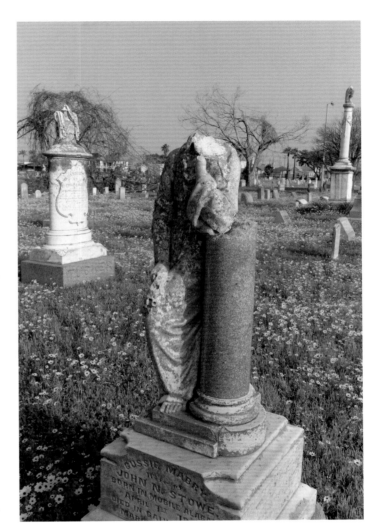

One morning this spring, I took a self-guided tour of the Galveston cemeteries, recalling a picture I saw on the Internet in the days after Hurricane Ike. It showed one of the old cemeteries completely flooded, with only the tops of the gravestones and the brick caretaker's hut showing above the surface of the water.

I was able to find the place without much trouble—the expanding City Cemetery on Broadway and Forty-second Street. Every block or so of the sprawling settlement has a new name—the New City Cemetery (with a headless saint presiding) giving way to the Evergreen and the Oleander, as you move westward. At the far end, a gateway marked "Hebrew Benevolent Society" declares the historic place of Abraham's progeny in the founding and growth of Galveston. On this side of the cemetery, the newest, German names prevail among Jews and Christians— Kaiser, Krausse, Hahn, Oldenburg—a lesson in Texas immigration history.

The dates on the headstones go back to the mid-1800s, when Galveston first boomed, a time that coincided with the perpetual care movement in the funeral industry. It was a civic development in the new democracy of America. Public graveyards came to replace churchyards as the favored site for burial. Families bought plots with the assurance that their investment guaranteed long-term custodial care, in case the family line died out—the kind of care once supplied by the church. Modern secular society demanded new ways, though the old beliefs remained. The dead needed a place to rest in peace, according to the theology of the old Christians, who understood death as a long sleep

before the day of Christ's return and the final judgment. The New Testament typically says that believers "went to sleep" rather than died. In this way of thinking, the grave is like a way station or a house—as the poet Emily Dickinson said, with its "Cornice—in the Ground." And the cemetery is like a city demanding perpetual care.

As with the rest of the city, the cemetery at Galveston demands a lot of care. The cracked walkways between the rows of graves are slanted and sunken. I realize, as I stroll there on a quiet Sunday morning, that I'm walking in an emergency drainage system that doubles as a concrete sidewalk. Unlike New Orleans, where the graves are all above ground, most here are placed underground in the traditional manner. The water table doesn't rise up to confound the gravedigger as it does in New Orleans. The natives of Galveston—going back even to the time of Cabeza de Vaca—were always able to bury their dead.

But with the constant threat of flooding, resting in peace might present a problem. During Hurricane Ike, a few caskets in new graves were gruesomely unearthed in nearby Orange, Texas, including one that held the recently buried remains of the legendary blues musician Clarence "Gatemouth" Brown, a native of Orange. At the big suburban cemetery out by Fifty-ninth Street in Galveston, I saw a tall stack of concrete vaults, the kind that the mortician tried to sell Jackie and me when her dad died up in Kansas. The vault, he said, would ensure that the casket would stay airtight in perpetuity. Less worried about the comfort of the dead than our ancestors may have been, we passed on the offer and buried the coffin unprotected

in the deep topsoil of the Great Plains. It was a wise decision, according to my friend who grew up the son of a small-town mortician in Texas. The family had occasion to open a grave or two, he told me, and had first-hand proof against the claims for the reliability of the sunken vaults. Maybe in Galveston, though, the vaults would serve a different purpose—not to keep the elements out so much as to hold the coffin in the ground.

These morbid thoughts drift as I survey the quiet graveyard. A low brick wall crumbles where salt water may have soaked it during the hurricane. In the sandy dirt nearby, wildflowers sprout. Showy primrose is the star on this late-spring day; its open pink cups carpet the cemetery's edge. A magic lily stands there too, like a pink miracle clinging to a stalk with no green leaf in sight.

Watching the rebuilding of Galveston after Hurricane Ike reminds me of the barn swallows that were nesting on our back patio when we bought our house in College Station. They came back every year. At first we loved them. They became a symbol of home. But nature, even when it attains the status of the symbolic, is not always lovely. The birds made a considerable mess on the patio below the nest. Sometimes the young birds would get sick or weak and be cast to the ground to die, heartlessly it seemed to us. Once a whole nestful died and fell to the ground and were covered by ants by the time we found them.

No matter what happened, though, they came back each year. The second and third generations returned too and began to colonize other parts of the house and yard. It's a common practice in well-kept neighborhoods like ours to knock down the mud nests and wash away the traces, but the law forbids it. The 1918 Migratory Bird Treaty Act protects the nests of native birds. Destroying them is ineffective anyway: the swallows will keep coming back and trying to rebuild.

When we finally enclosed the back patio to make the screened porch, for a couple of seasons afterward we would see the swallows circling and chirping wildly, unable to satisfy what instinct demanded. Finally they gave up and moved the clan elsewhere—or so we thought. This year we discovered they had only moved to another side of the house.

The homing instinct of the swallows is like the Galveston Spirit. The islanders keep coming back when a power they can't control blows the nest away, washes it off the island, and strives to reduce their home place to an uninhabitable bump in the surf of the Mexican Gulf.

As for the rest of us—the guests and perennial visitors—we can feel the pull of the Galveston Spirit too, the lure of nature, history, fantasy. Going there may start, as it did with me, as a mere diversion from daily life—then become a habit, a ritual, and finally a seasonal pilgrimage that puts a person in touch with something not available in daily life, something deep that demands to be satisfied.

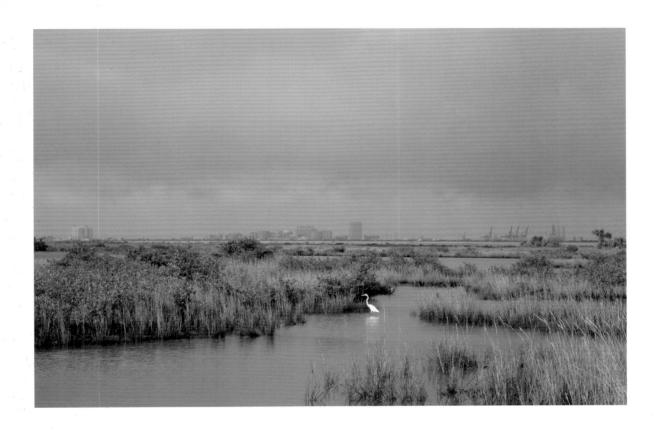

South from Boddeker Road, northeastern Galveston Island (above)

East from Tiki Island across West Bay (following two pages)

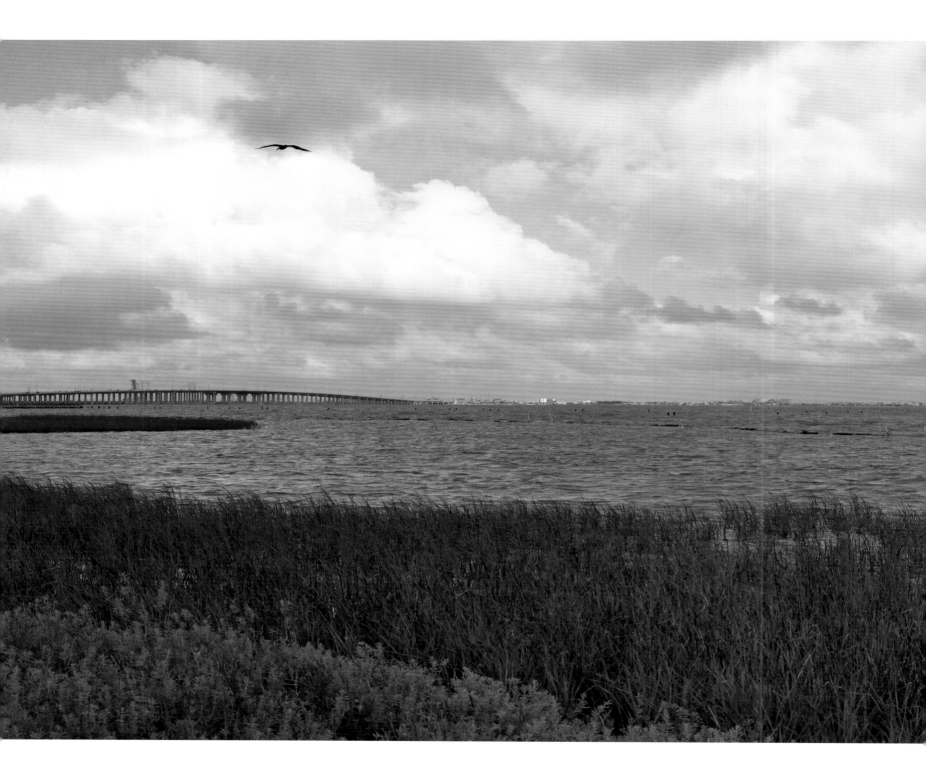

South from Seventy-first Street near Broadway (left)

East from Jack Johnson Boulevard at Church Street (right)

Alley between Avenue M and Avenue N at Thirty-seventh Street

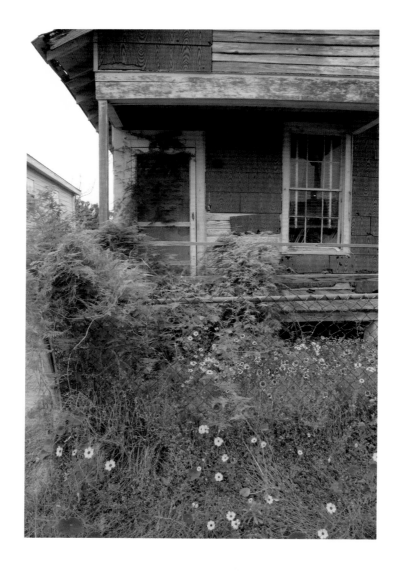

Thirty-seventh Street (left) and Avenue K (right)

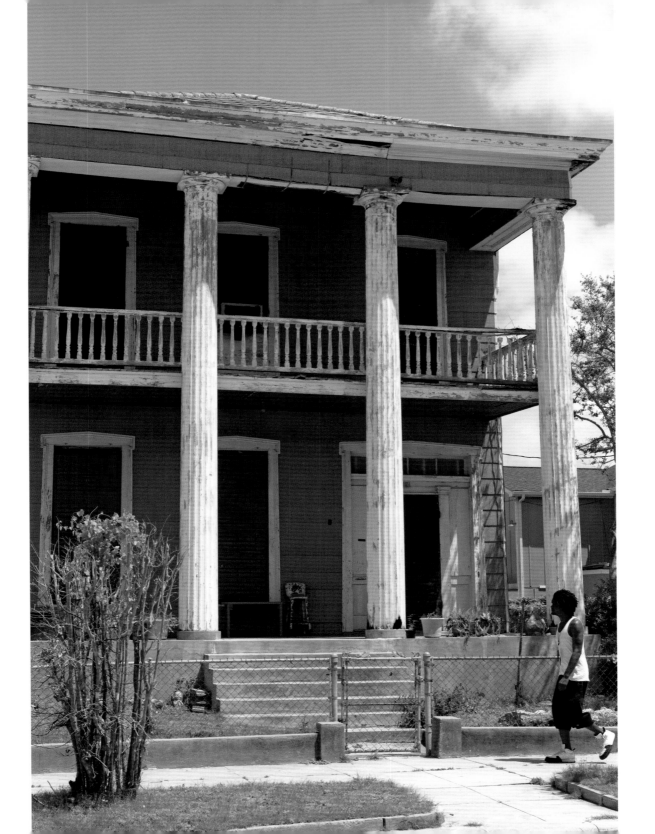

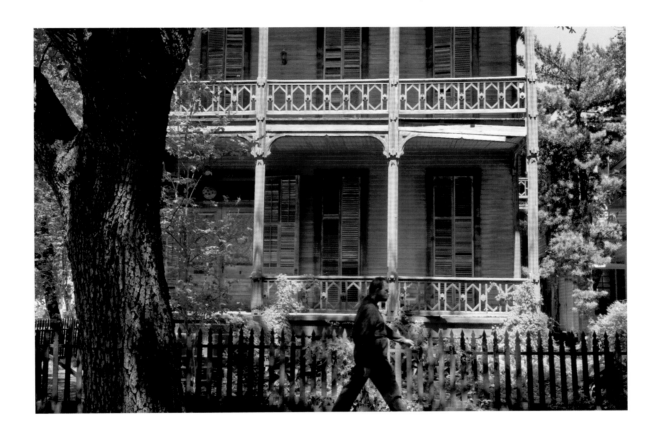

Church Street (left) and Post Office Street (right) in the East End
Historical District

Post Office Street in the East End Historical District

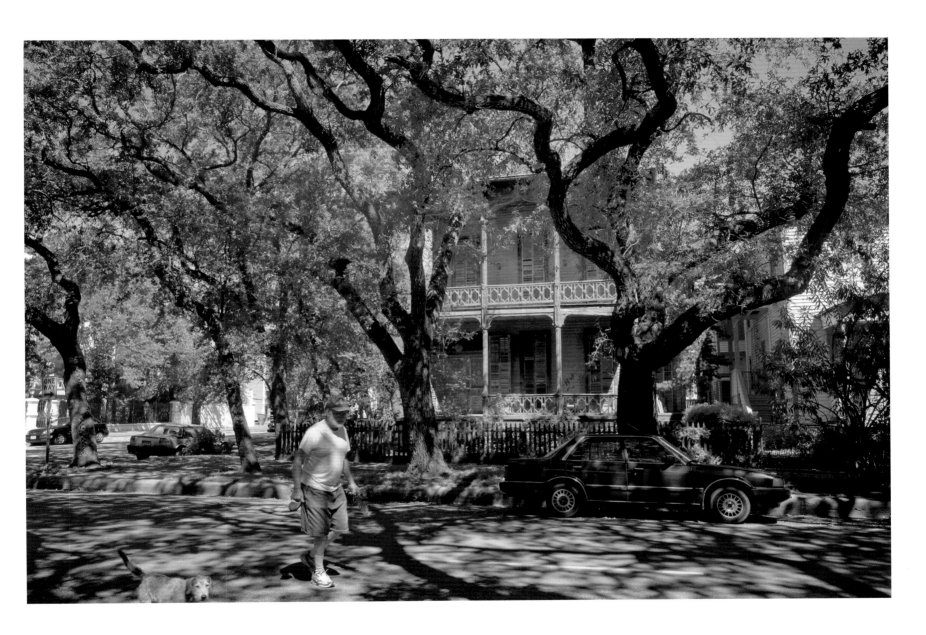

The Strand

Shopping on The Strand

Sign and photos at Smitty's Bait Shop, Broadway Street

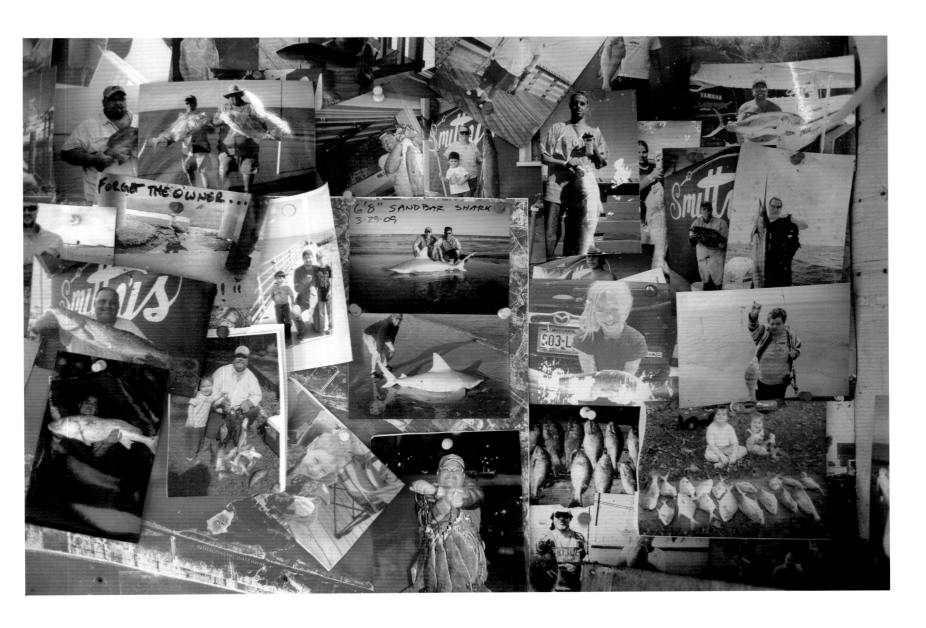

Bait shop sign and fishing on Boddeker Road

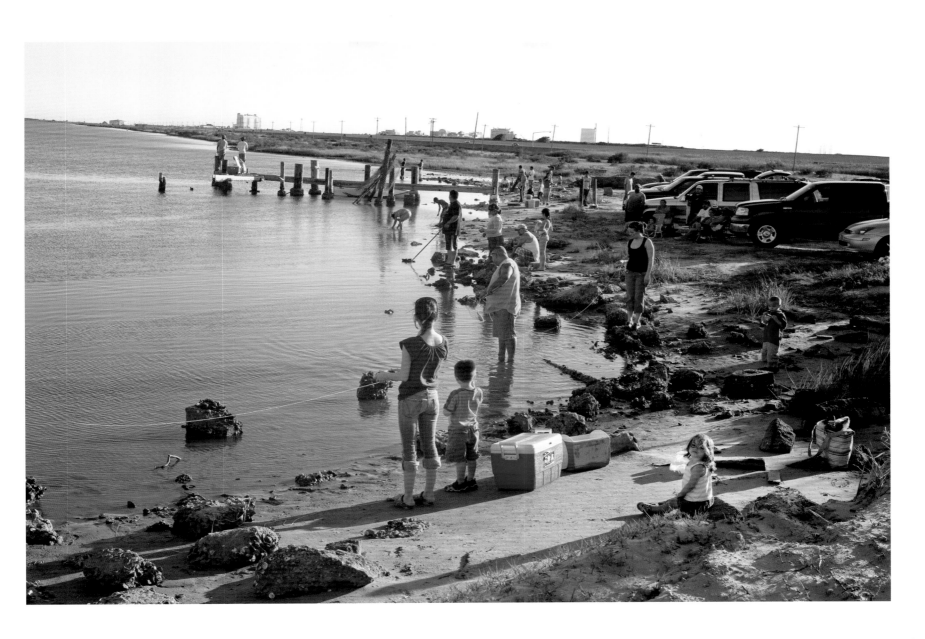

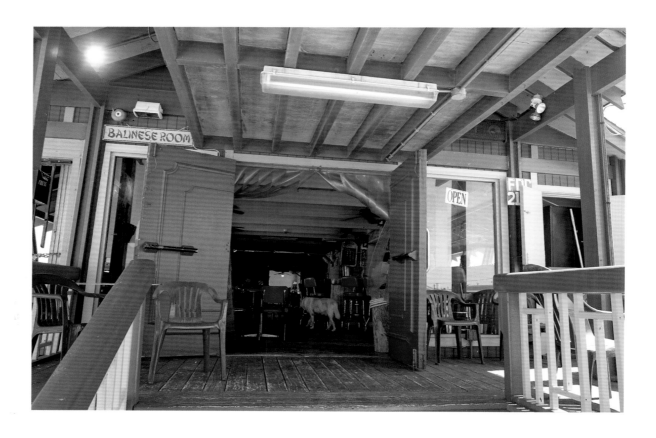

Entrance to the Balinese Room (left) and a new condominium
(right) on Seawall Boulevard before Hurricane Ike

Miniature golf (left) and tourist restaurant (right) on Seawall Boulevard

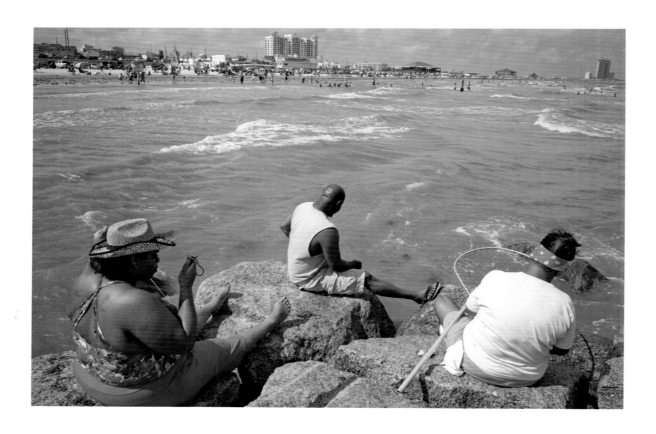

Jetty fishing for crab (left) and beachfront, seen from the Balinese
Room, including the Hotel Galvez (right)

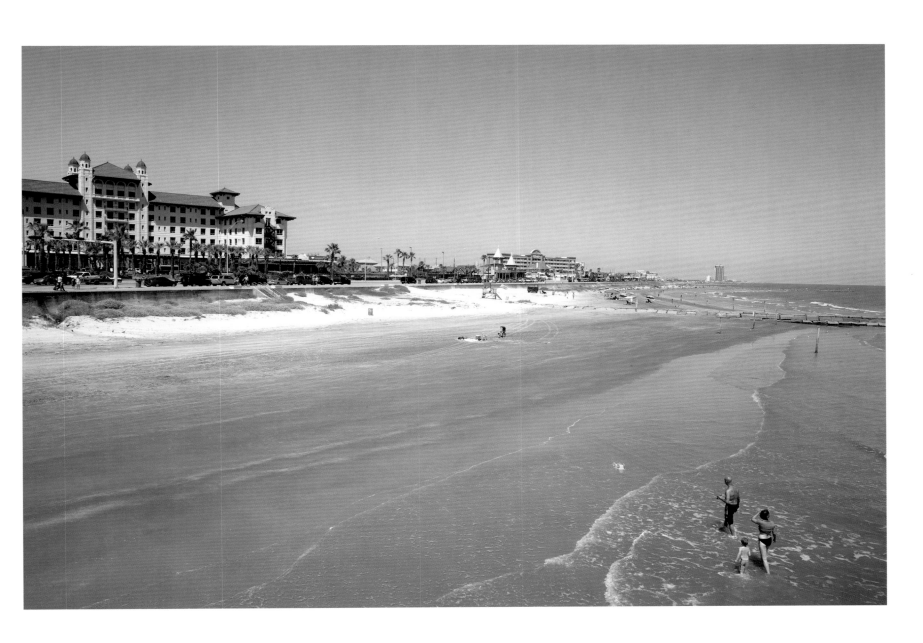

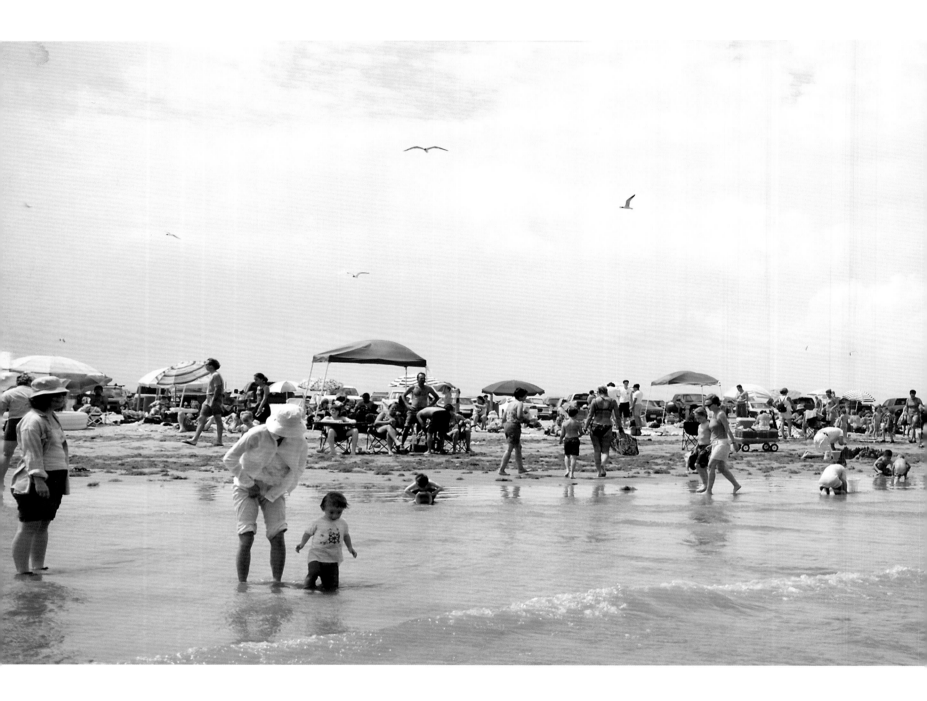

Stewart Beach

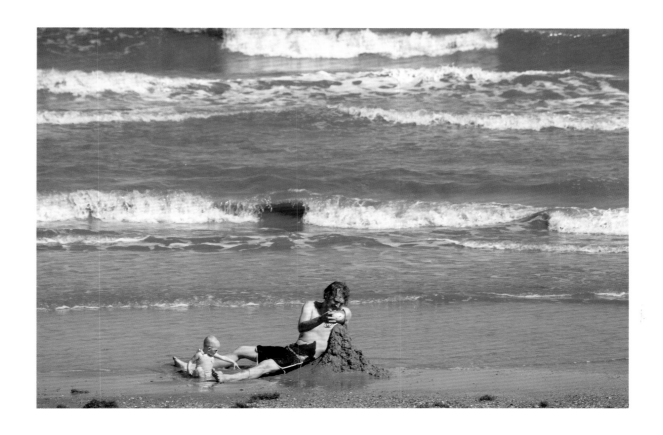

Stewart Beach

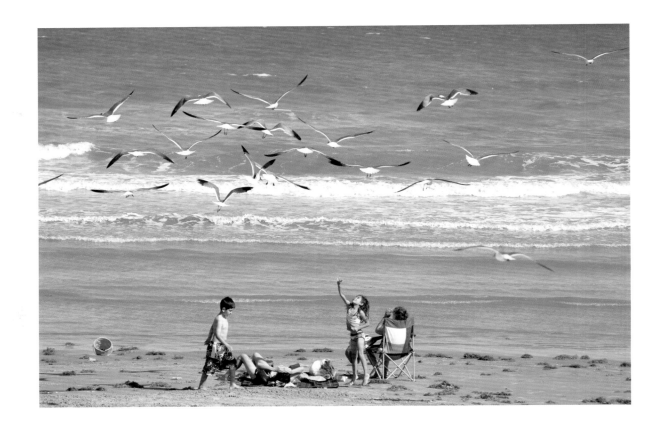

Stewart Beach

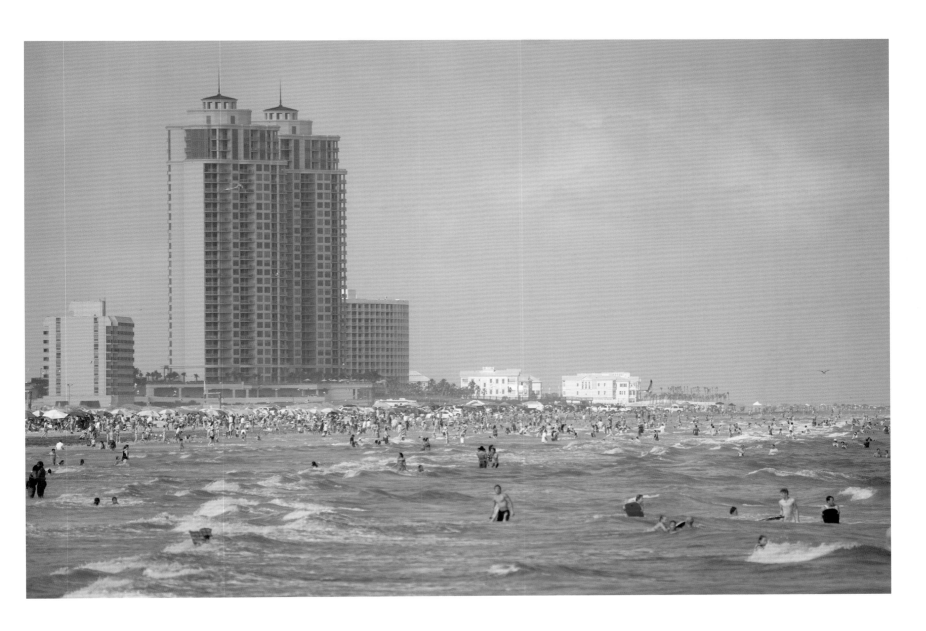

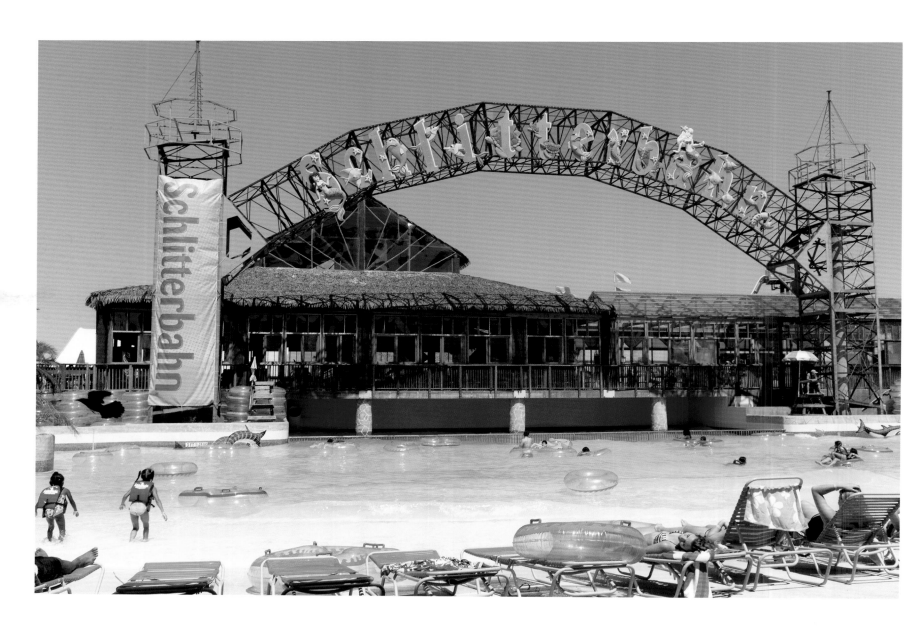

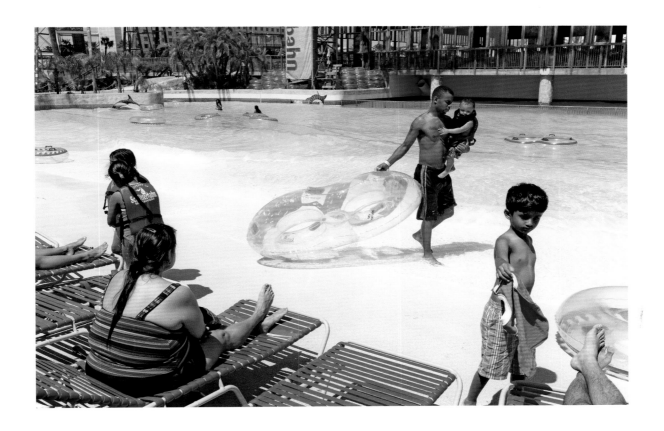

The main beach at Schlitterbahn

On the Boogie Bahn (left) and the Lazy River (right) at Schlitterbahn

In the Moody Gardens Aquarium Pyramid

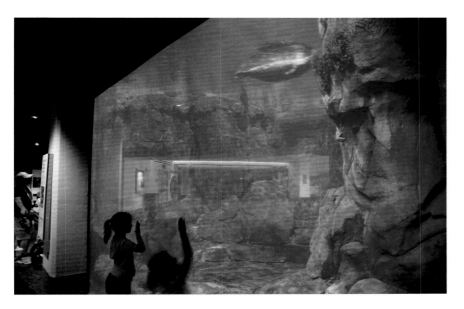

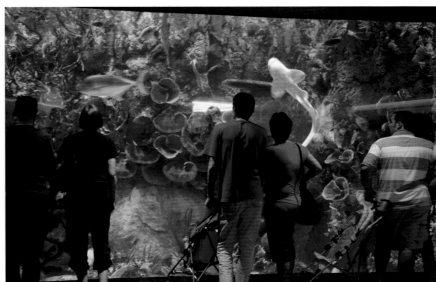

Touring Moody Gardens (left)
Family photos at the Rainforest Cafe, Seawall Boulevard (right)

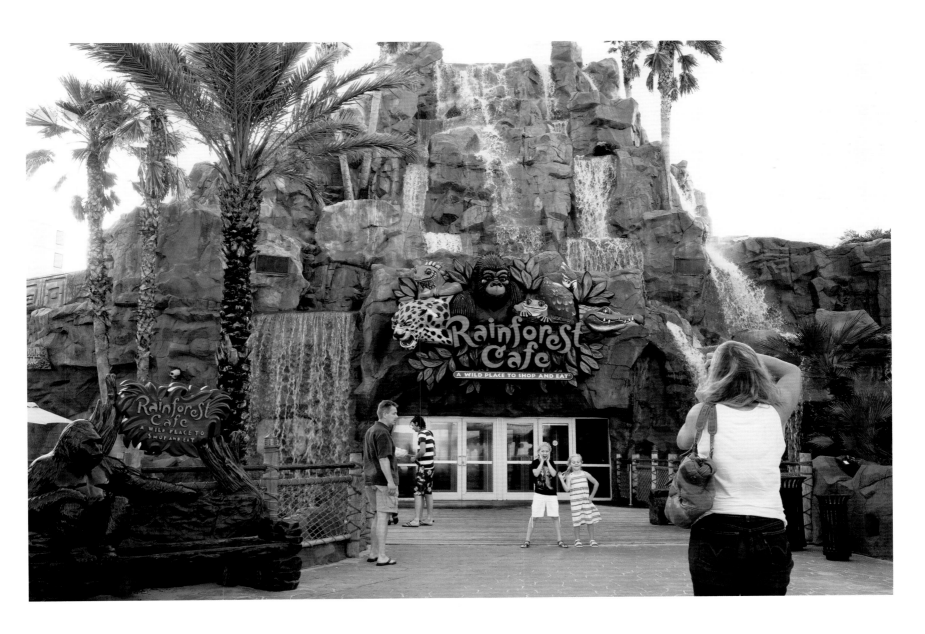

In the Rainforest Cafe, Seawall Boulevard

Tourists on the seawall

Gravestone, City Cemetery (also known as Broadway Cemetery) (left)

Fishing at Sixty-fourth Street and Avenue L (right)

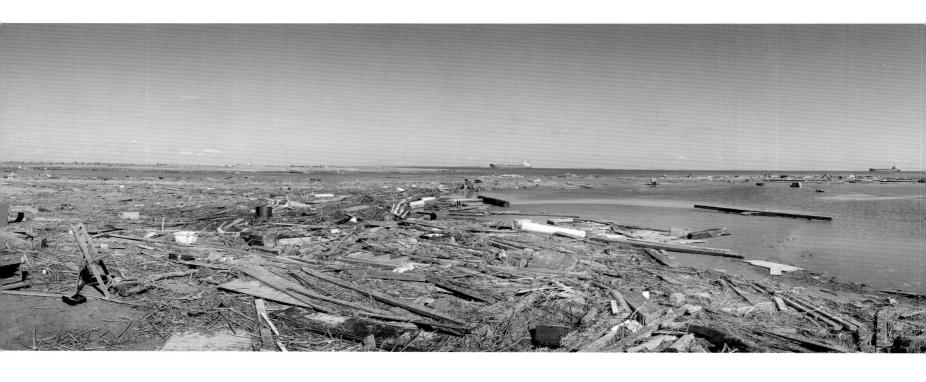

After Hurricane Ike, at the northeastern tip of Galveston Island

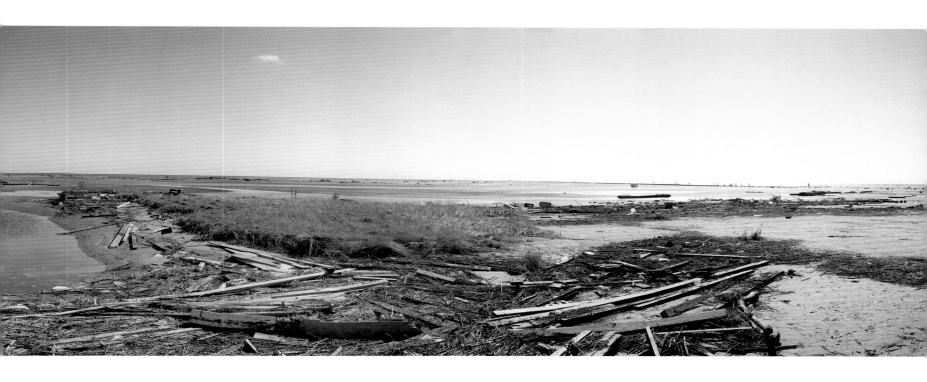

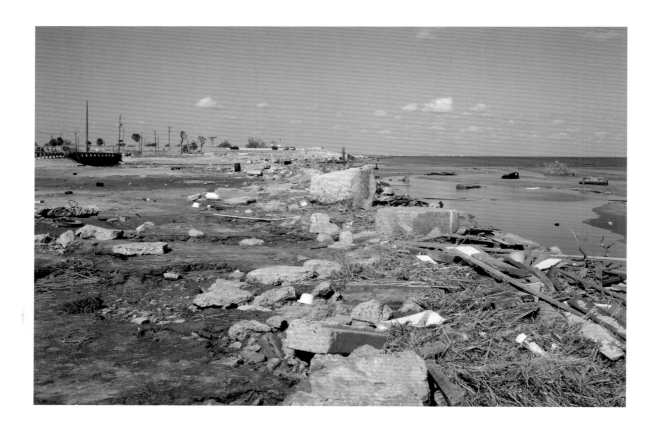

After Hurricane Ike, the northeastern tip of Galveston Island (left) and the
pilings that once supported the Balinese Room (right)

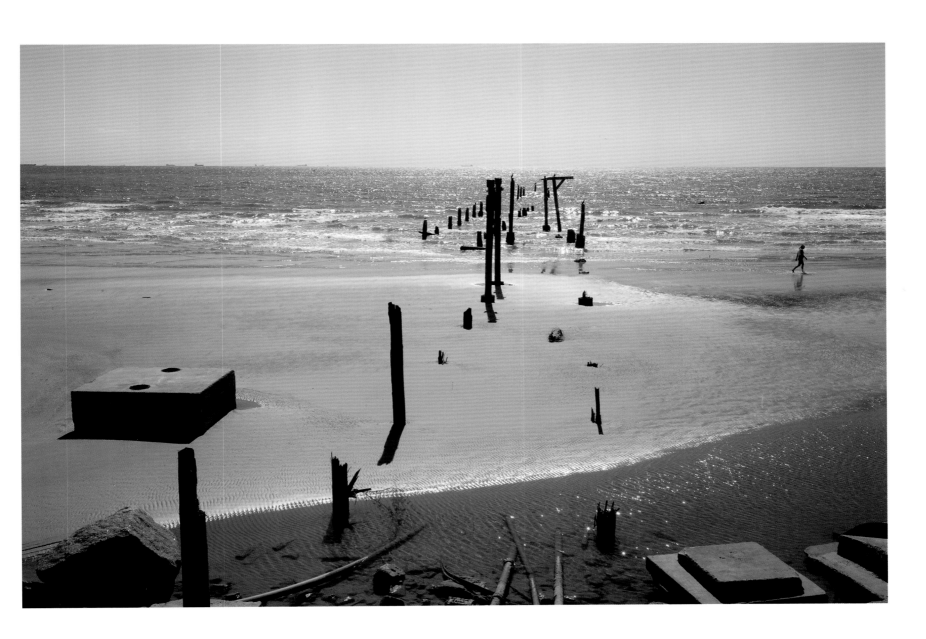

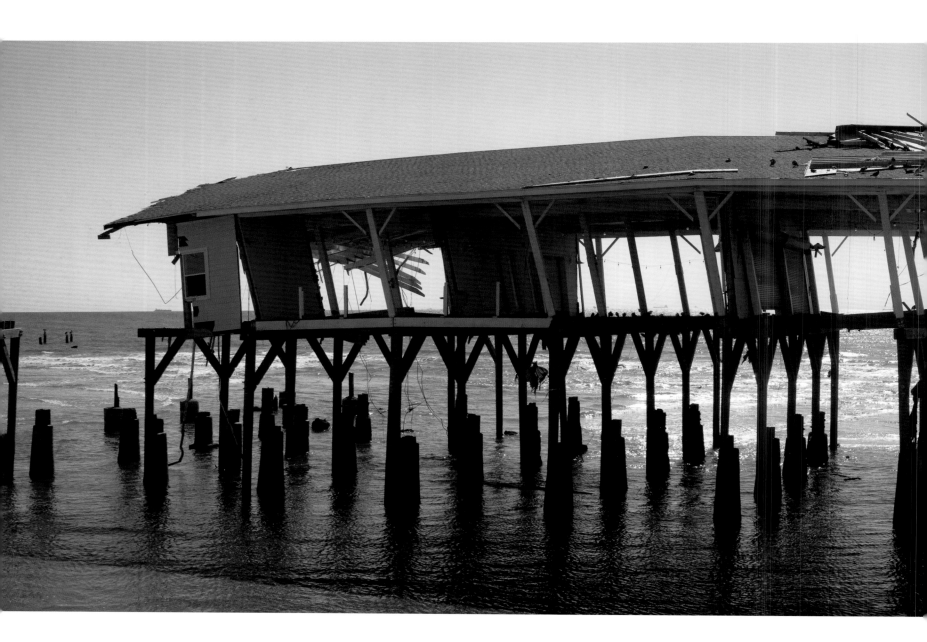

After Hurricane Ike, the ruins of Hooters

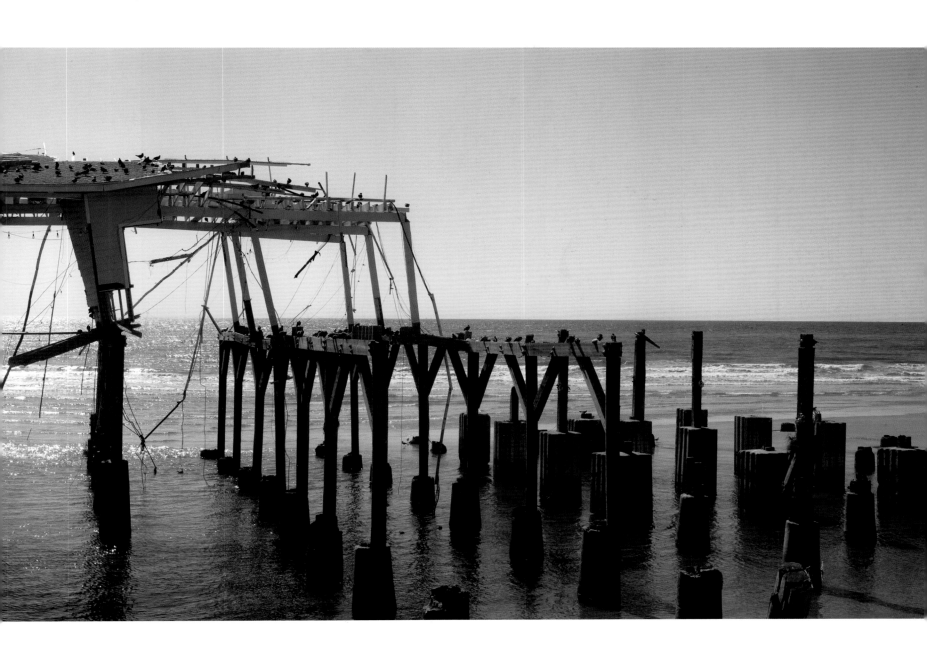

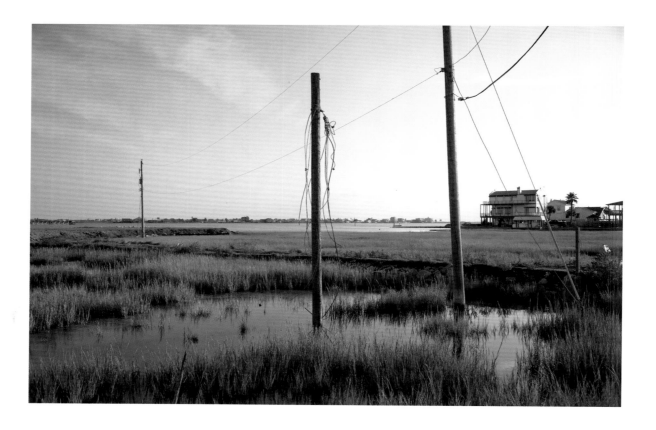

After Hurricane Ike, near Bayou Shore Drive and Broadway Street

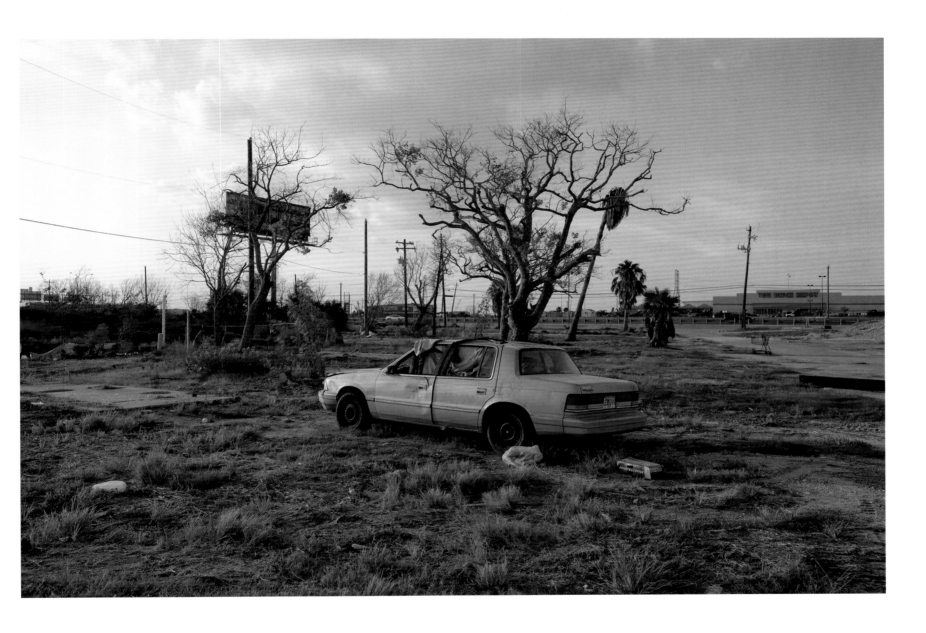

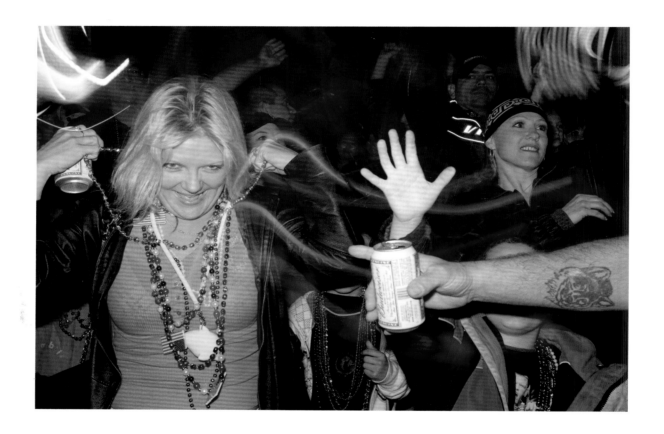

Knights of Momus Parade, Mardi Gras

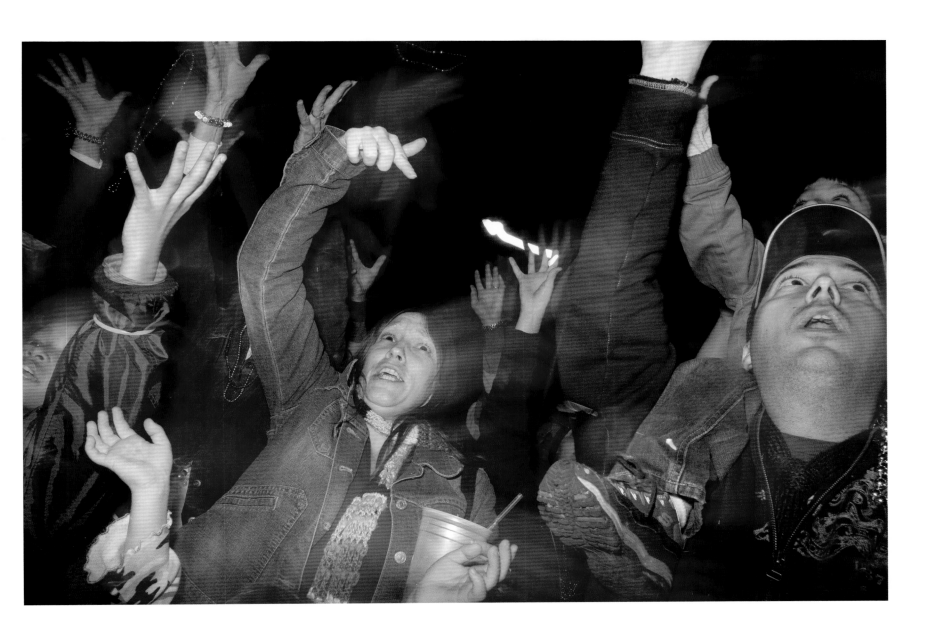

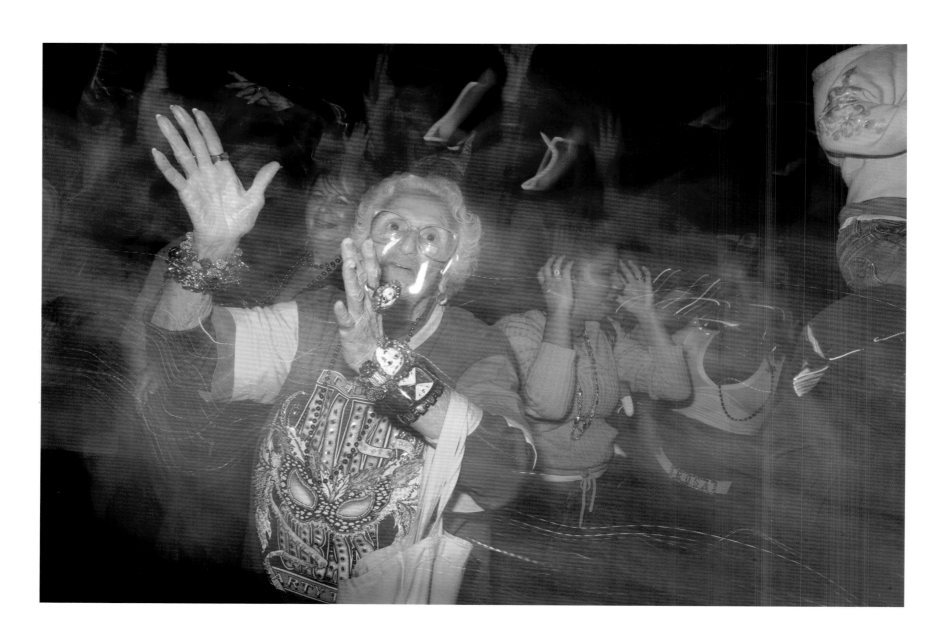

Knights of Momus Parade, Mardi Gras

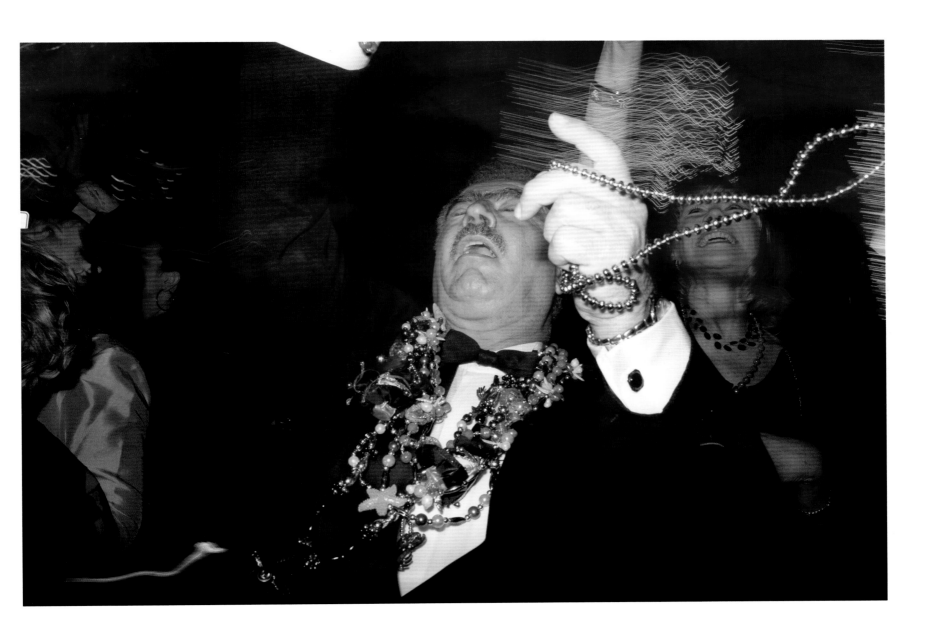

Broadway Cemetery

Palm trees and abandoned warehouse, Thirty-third Street (left)
Winnie Avenue at Thirty-third Street (right)

Ruins of a restaurant (left) and the Flagship Hotel (right) on
Seawall Boulevard

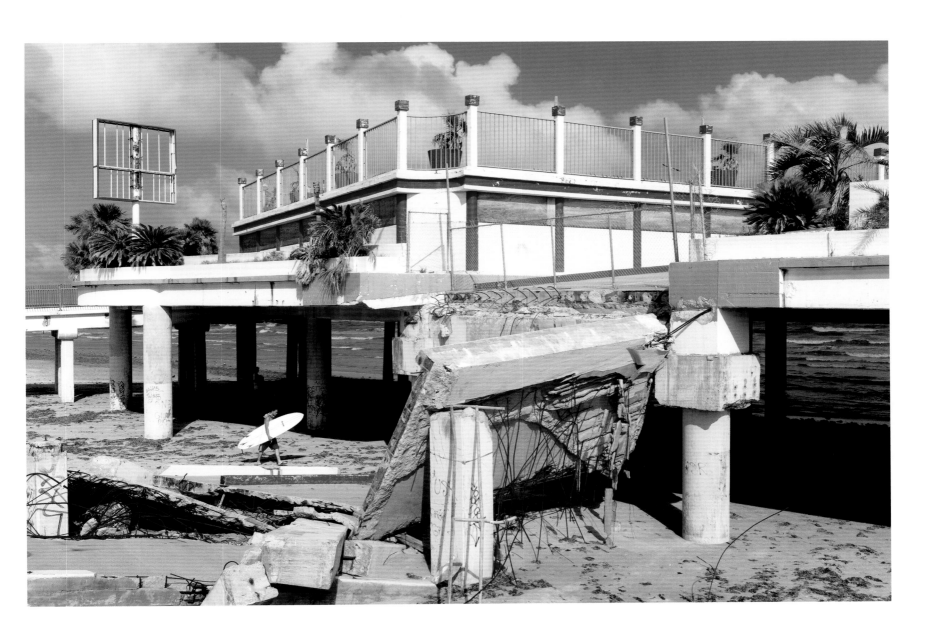

North from the northeastern tip of Galveston Island

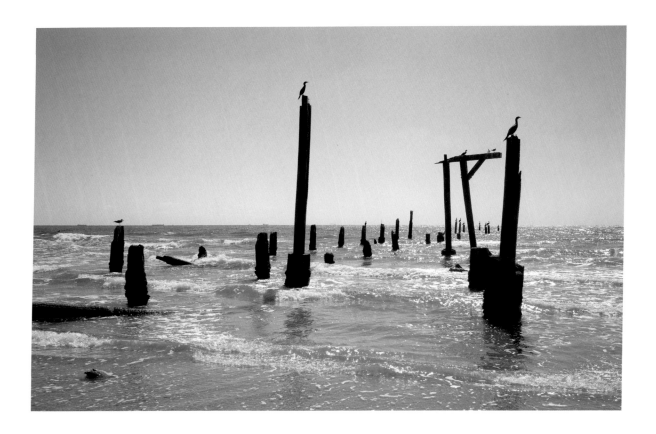

Ruins of the Balinese Room after Hurricane Ike